PUBLISHER'S NOTE

Japanese design has a unique place among the world's artistic traditions. Universally renowned for the cultivation of beauty in all things, the Japanese have developed a mastery of line and composition that has won them the admiration of artists far beyond their island shores. Japan's artistic debt to China (and, to a lesser extent, to Korea, Tibet and India) is considerable, but the native genius of generations of Japanese artisans and craftsmen, especially during centuries of self-imposed national isolation, has left the world a remarkable and distinctive design legacy.

The chief medium through which the design motifs in this compendium have come down to us is that of the wood-block-printed book. Invented in China and introduced to Japan by Buddhist missionaries in the first millennium of the Christian era, the technique of cutting designs in relief on blocks of wood for printing on paper has flourished in Japan ever since. The process was first used for the production of religious charms, some of which (dating from the eighth century) survive as the earliest known examples of printing. The art of the woodcut reached its zenith in the work of the *ukiyo-e* ("floating world") school of the seventeenth, eighteenth and early nineteenth centuries. A few examples of design by Katsushika Hokusai (1760–1849), the world-famous "old man mad about drawing" and master of this school, are included here.

Most of the graphic material in this collection is, however, unattributable. The sources are, in the main, retrospective collections of traditional design published during the Meiji Restoration (1868–1912), a period of tremendous social and cultural upheaval that marked the beginning of Japan's modernization. Preeminent among the sources are several albums of *mon* (family crests), which provided the charmingly decorative, mostly circular devices that abound on these pages.

Crests came into use in the Imperial court of the eleventh century as adornments on formal costumes. The practice of wearing these badges symbolic of family names spread from the courtiers to the samurai class, who displayed them on banners, flags and weapons. In the introduction to *Japanese Design Motifs*, a compilation of 4,260 illustrations of crests (Dover, 1972, 22874-6), Fumie Adachi points out that "since identification on the battlefield became the main purpose of the crests, the warriors designed emblems that were simple, conspicuous and easy to recognize."

Later social developments allowed the diffusion of these erstwhile symbols of privilege to the lower orders of society. The use of the crests broadened to other decorative applications, and the designs themselves became more symmetrical.

This collection also includes examples of book illustration and some line renderings of ceramic and textile design. Their presence varies the rhythm of the pages, demonstrating the versatility of the Japanese imagination and suggesting a wide range of potential adaptations to three-dimensional media. There are full-page compositions of bold geometric design as well as vignettes of ethereal delicacy.

Many of the characteristic subjects of Japanese art are sampled here. The islands' flora is especially well represented, from the homely radish to the imperial chrysanthemum. Bamboo, cherry and plum blossoms, rice and cabbage, wisteria and pine all figure prominently, often in several arrangements on a single theme within the typically circular plan. While most of these designs are conventionalized according to ancient canons of heraldry, the draftsmen's keen observation of nature is evident in the faithful representation of floral anatomy.

Animal forms appear in somewhat less profusion than those of plants, but there are delightful interpretations of lions, elephants, dogs, cranes, parrots, turtles, butterflies and even a sea urchin. The dragons and demons of legend snarl and swirl over several pages, and there are a few treatments of human figures in traditional garb. Such everyday objects as fans, umbrellas, kites, tops, scrolls, packages and keys are depicted frequently. Religious symbols such as the fylfot, or Buddhist cross, appear both as decorative elements in figurative designs and as repeated patterns of pure form.

Because this book is intended for ready use by designers, illustrators and craftspeople, artist Carol Belanger Grafton has painstakingly redrawn the images to sharpen their lines and improve their reproducibility, preserving the subtlety and detail of the designs while smoothing over the imperfections of the original impressions. The visual interest of the material she has collected needs no further commendation. It is our hope that this sampling of traditional Japanese design motifs will enchant and inspire browsers and users alike.

Treasury of
JAPANESE DESIGNS
AND MOTIFS
for Artists and Craftsmen

Published in Canada by General Publishing Company, Ltd., 30 Lesmill Road, Don Mills, Toronto, Ontario.
Published in the United Kingdom by Constable and Company, Ltd.

Treasury of Japanese Designs and Motifs for Artists and Craftsmen is a new work, first published by Dover Publications, Inc., in 1983. For this volume Carol Belanger Grafton selected, redrew and arranged illustrations from *Karakusa moyō hinagata* (Patterns of arabesque designs), 1882; *Bambutsu hinagata gafu* (Picture book of all designs), 1882; *Hokusai moyō gafu, zen* (Picture book of Hokusai's designs), 1892; *Shin monchō daizen* (New complete book of crests), 1894; *Shindō iroha inmonchō taizen* (New complete work of crests), revised edition, 1900; *Kodai moyō shikizukō jō* (Picture book of the ancient patterns), n.d.; *Mon no izumi* (Fountain of crests), 1934; and several unidentifiable volumes of designs.

DOVER *Pictorial Archive* SERIES

Manufactured in the United States of America
Dover Publications, Inc., 31 East 2nd Street, Mineola, N.Y. 11501

Library of Congress Cataloging in Publication Data

Grafton, Carol Belanger.
 Treasury of Japanese designs and motifs for artists and craftsmen.

 (Dover pictorial archive series)
 1. Decoration and ornament—Japan—Themes, motives.
I. Title. II. Series.
NK1484.A1G7 1983 745.4'4952 82-17754
ISBN 0-486-24435-0

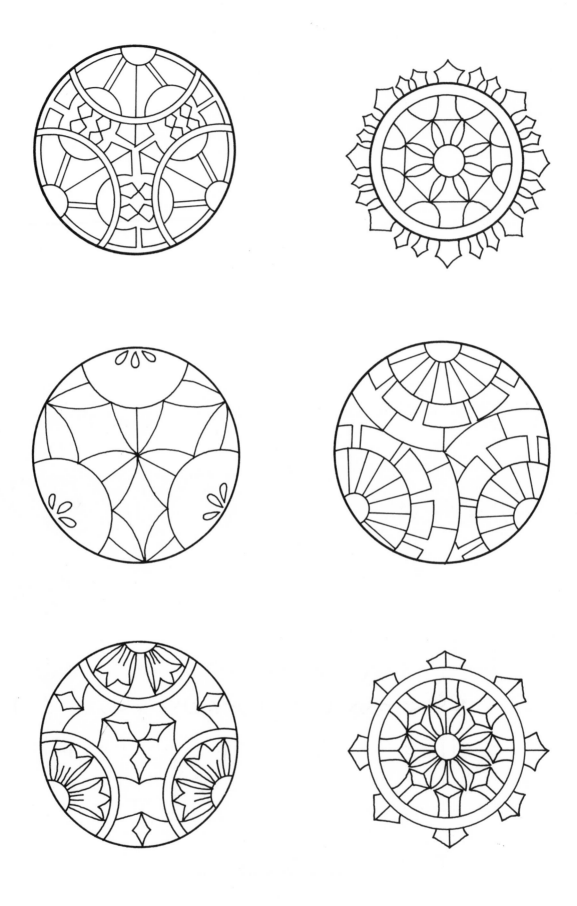

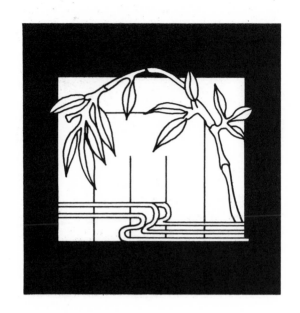

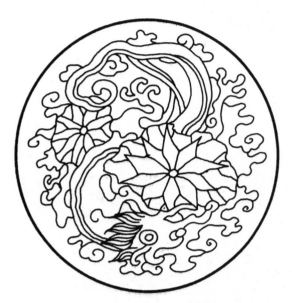

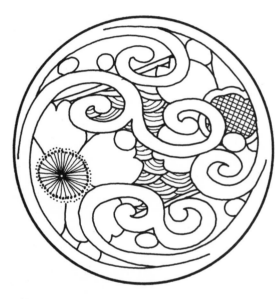

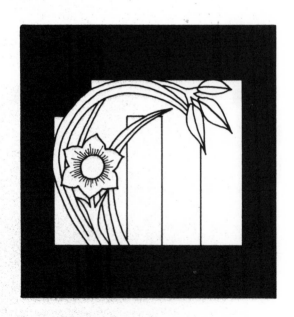

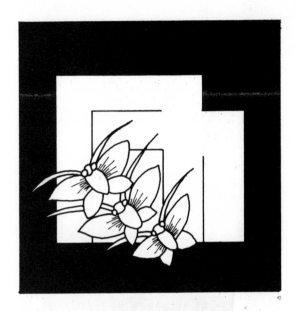

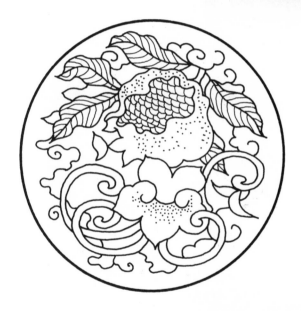

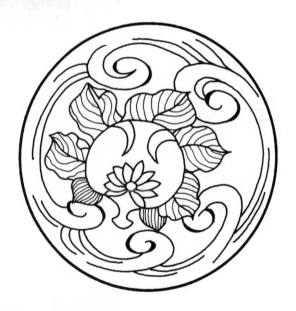

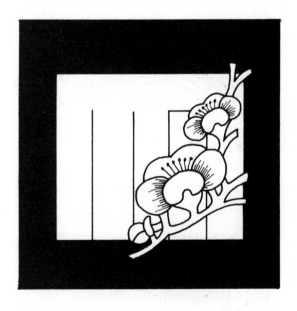

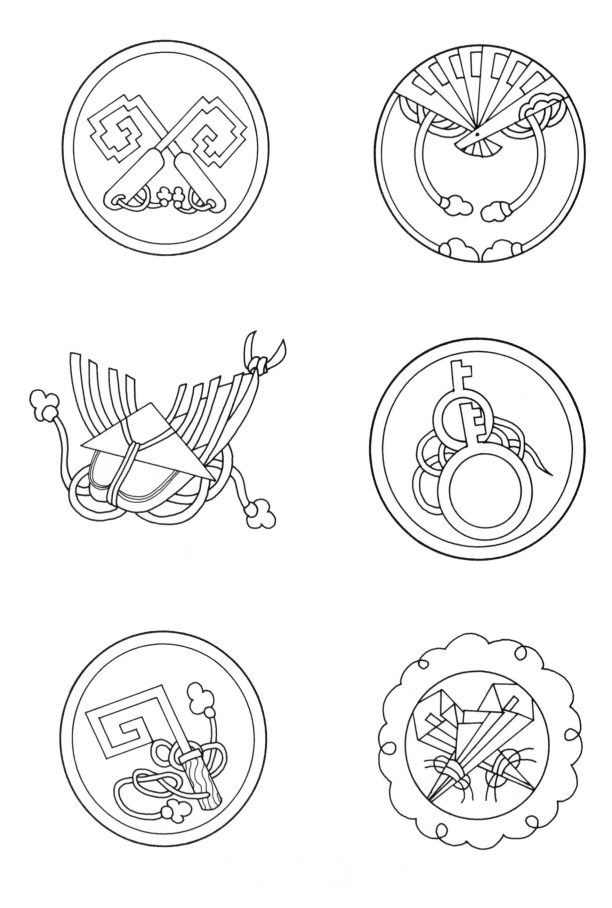

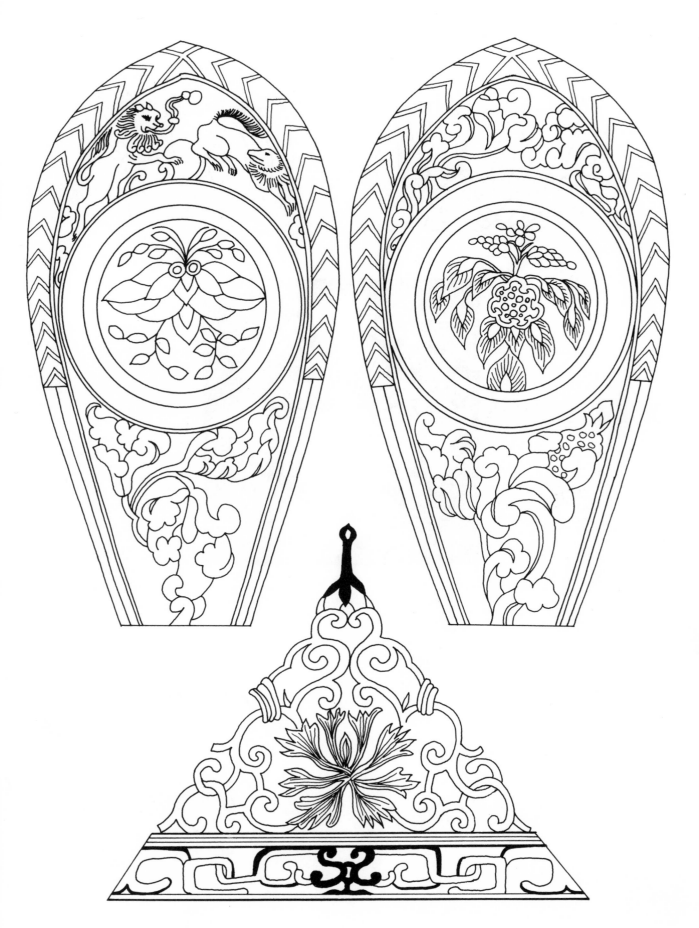

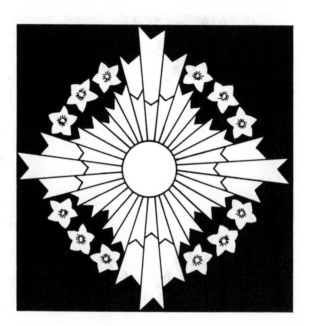

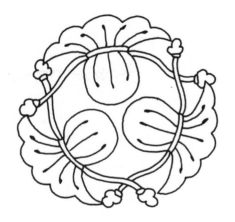

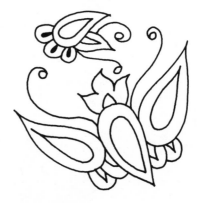

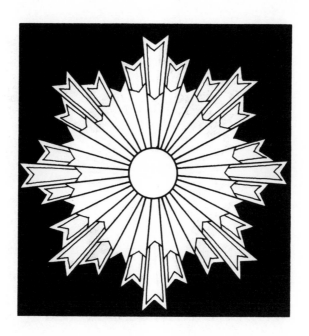

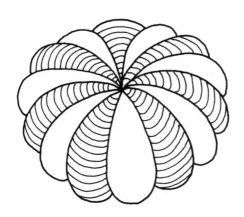

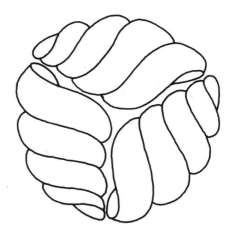

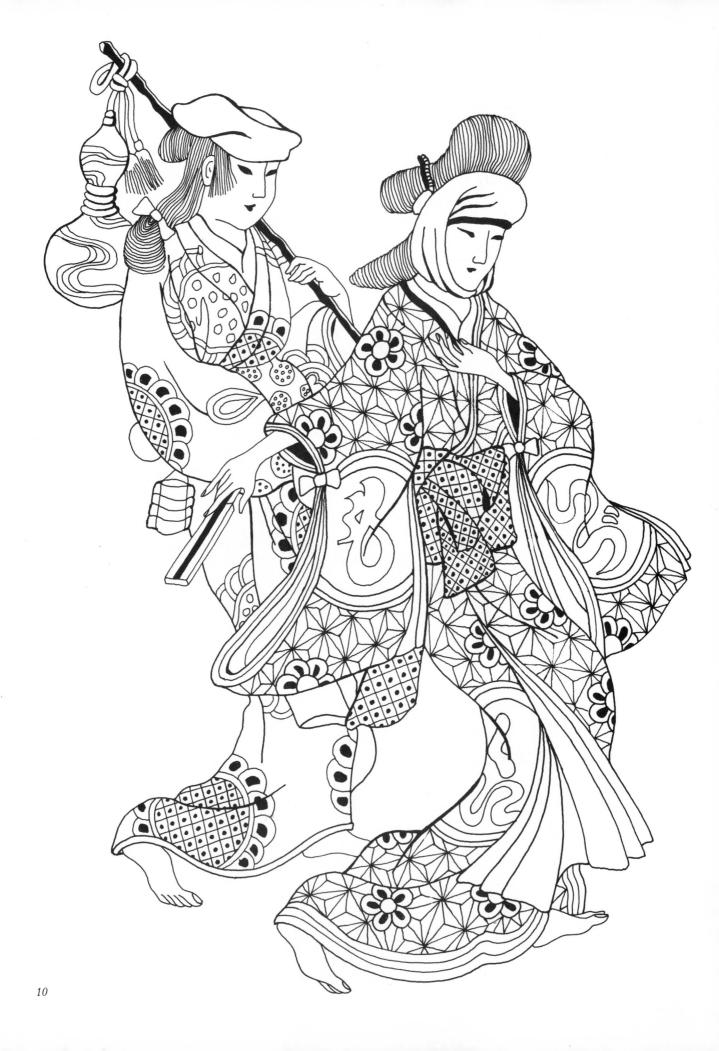

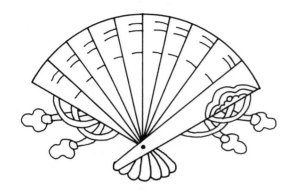

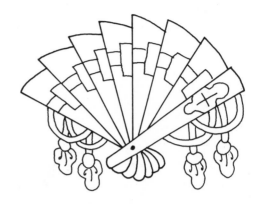

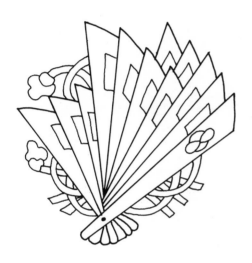

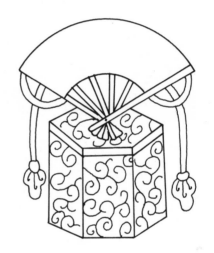

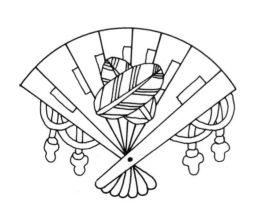

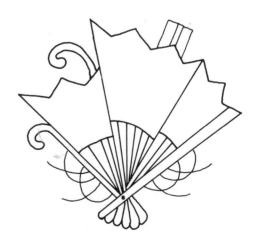

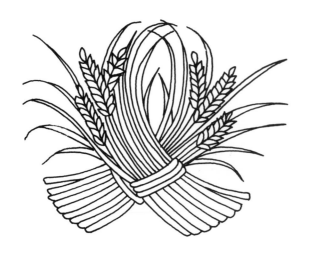

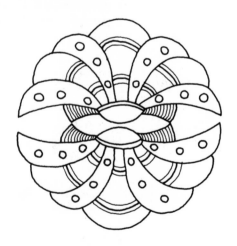

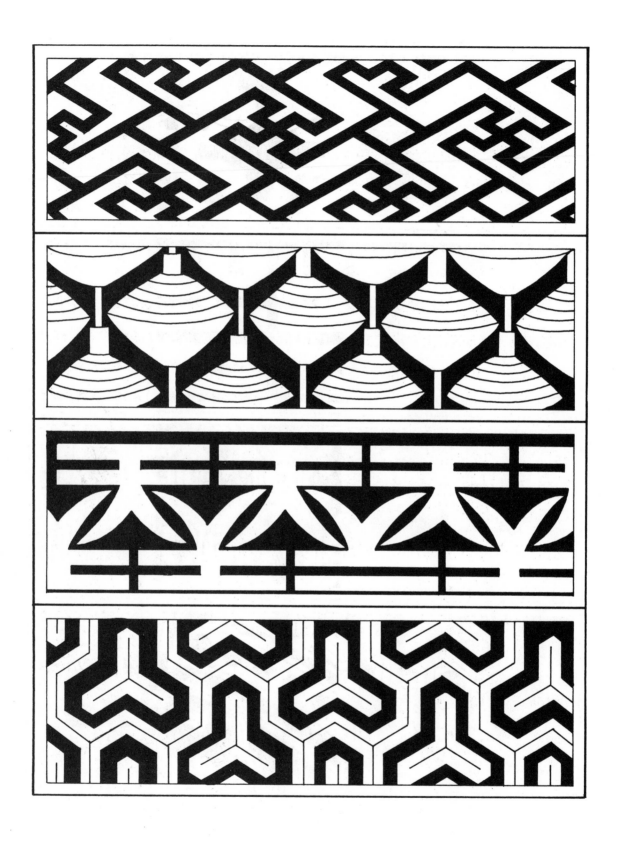

14

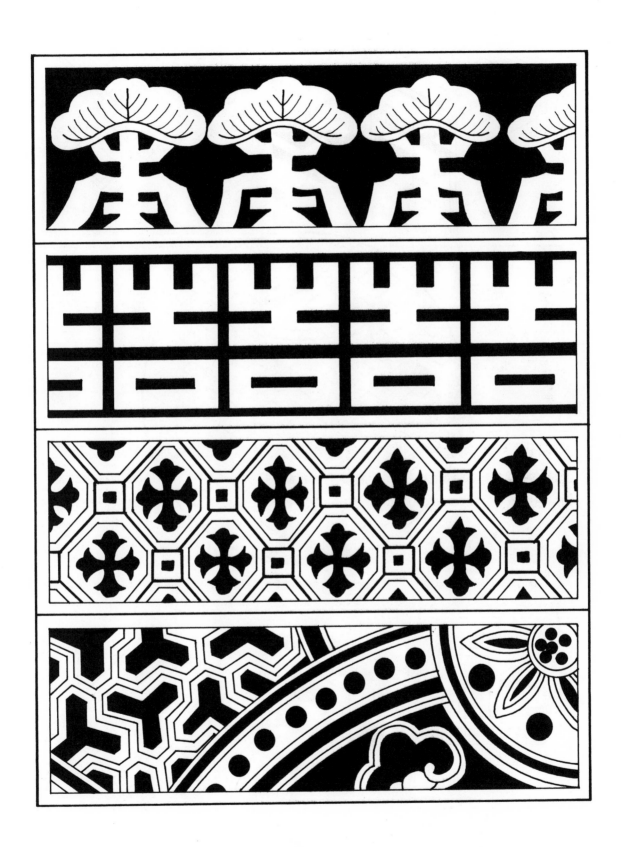

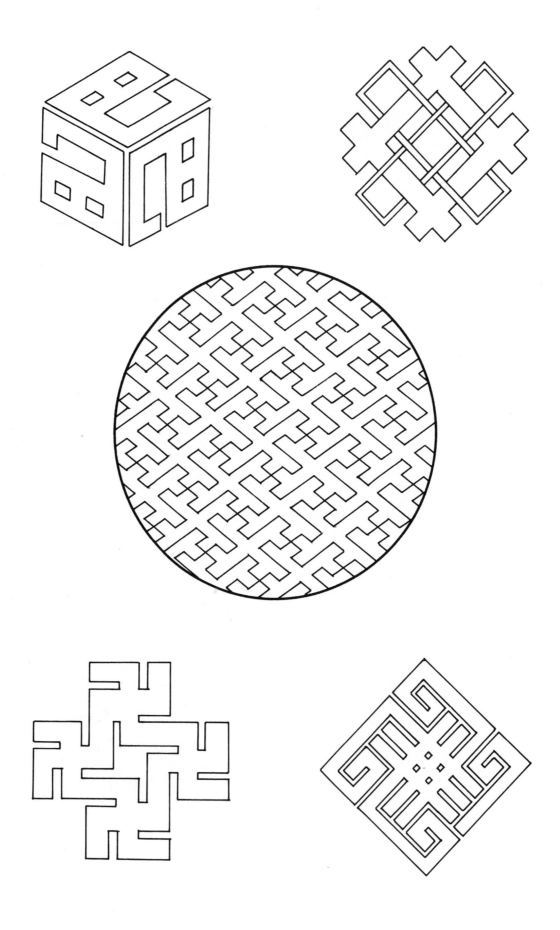

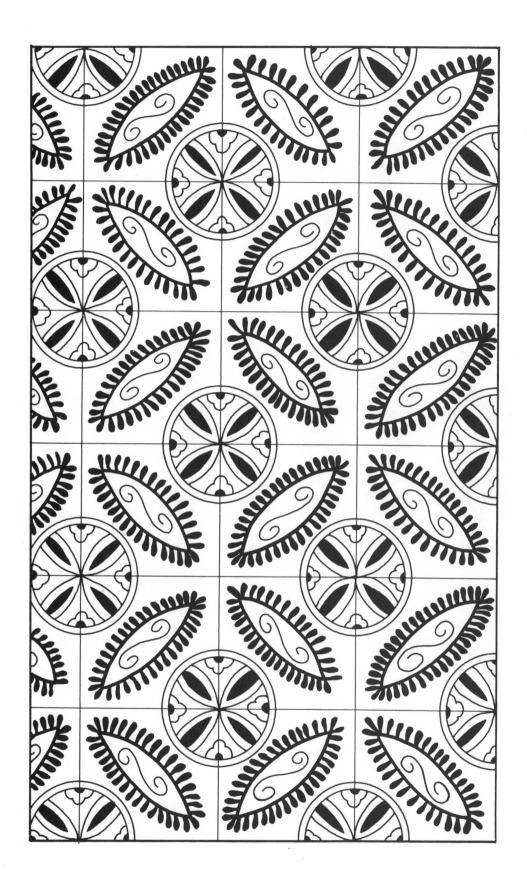

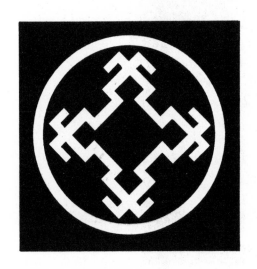

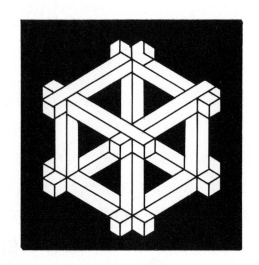

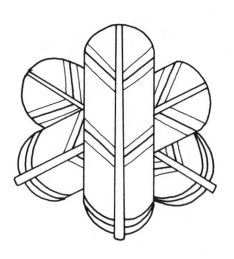

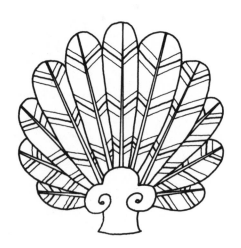

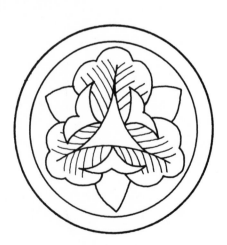

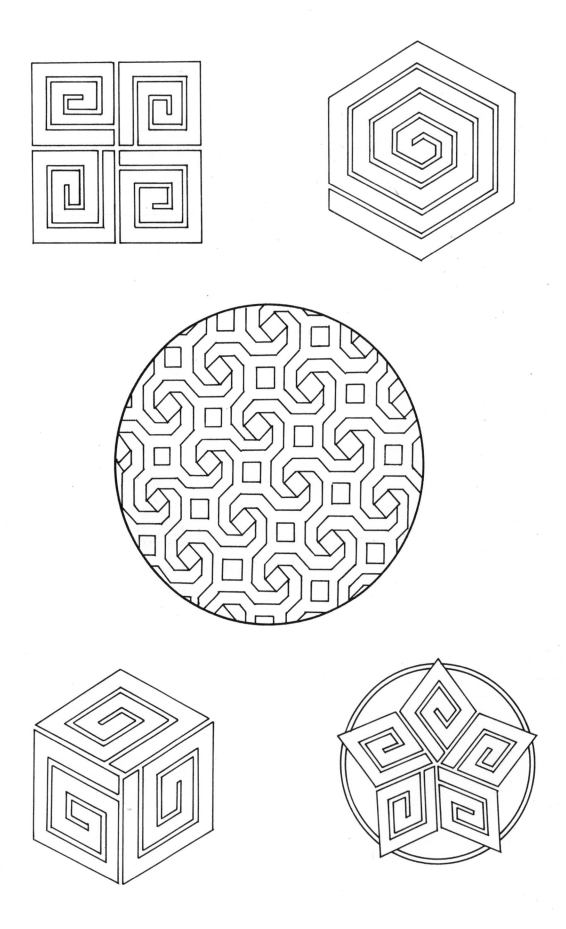

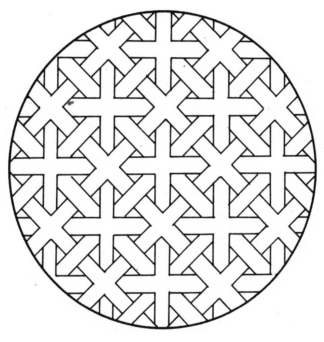

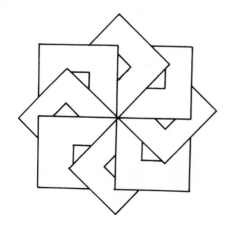

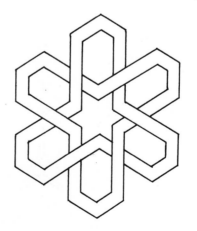

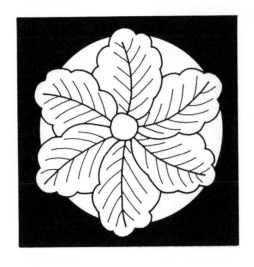

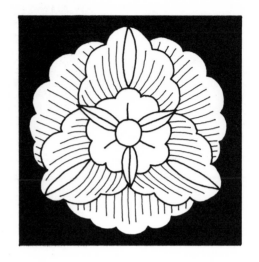

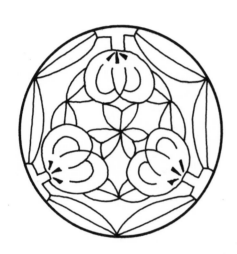

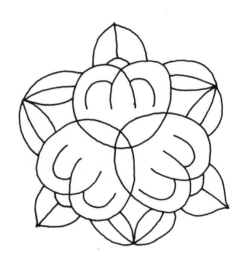

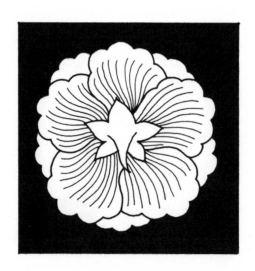

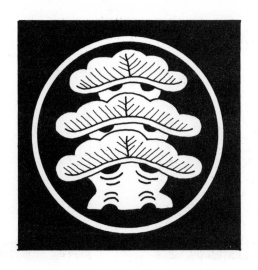

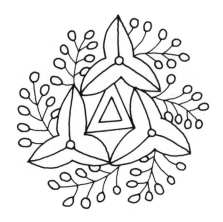

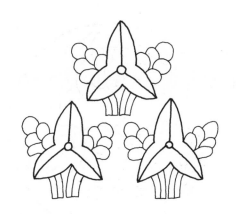

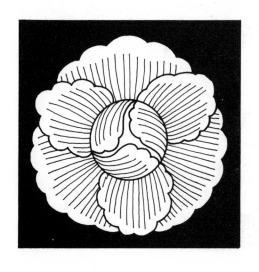

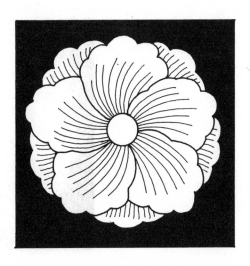

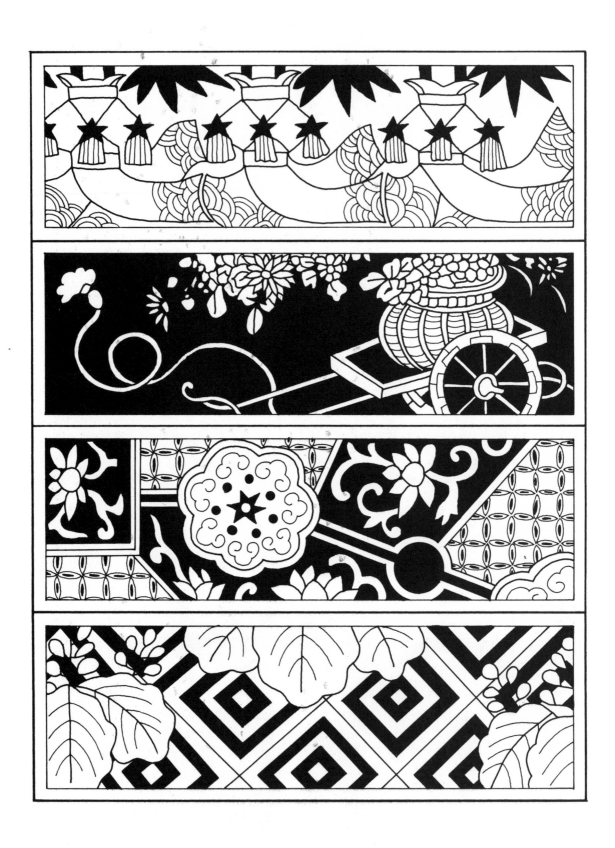

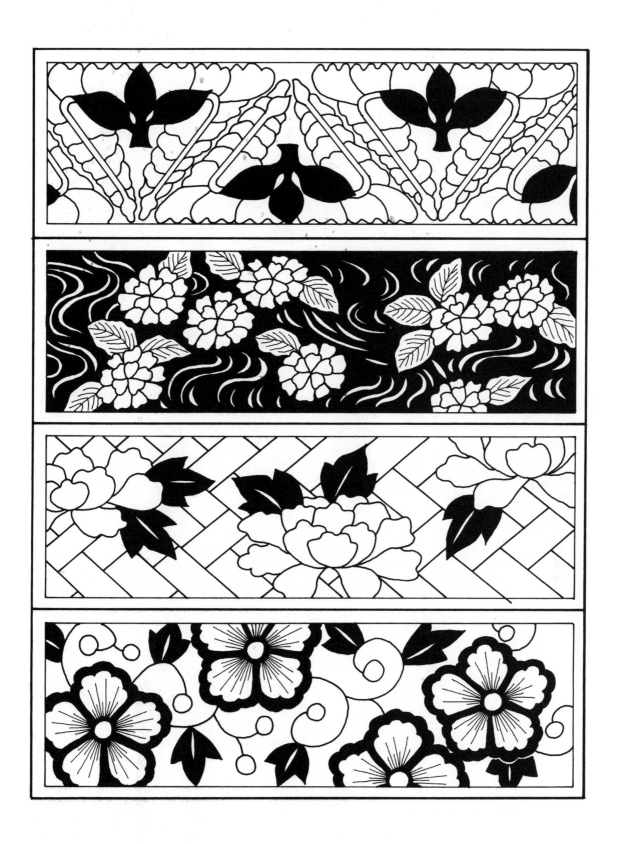

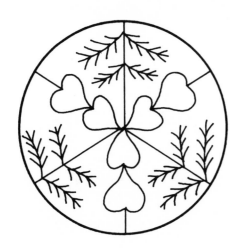

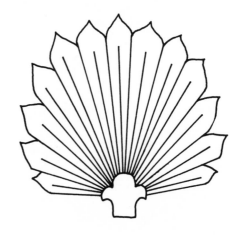

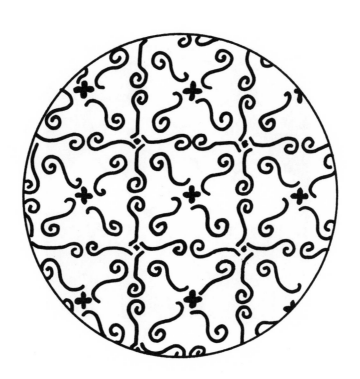

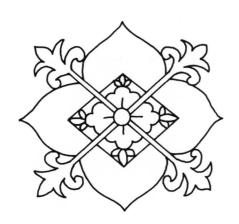

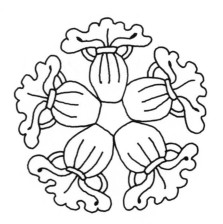

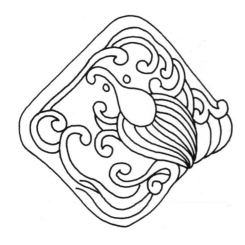

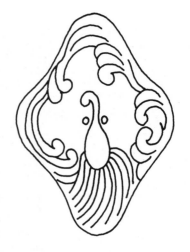

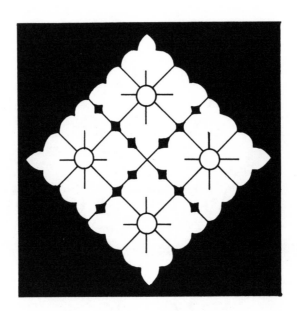

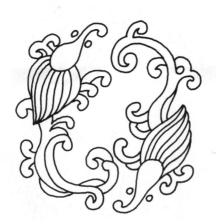

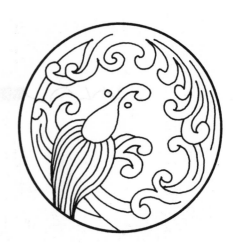

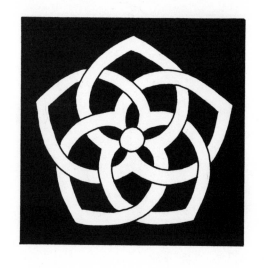
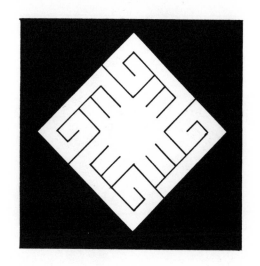

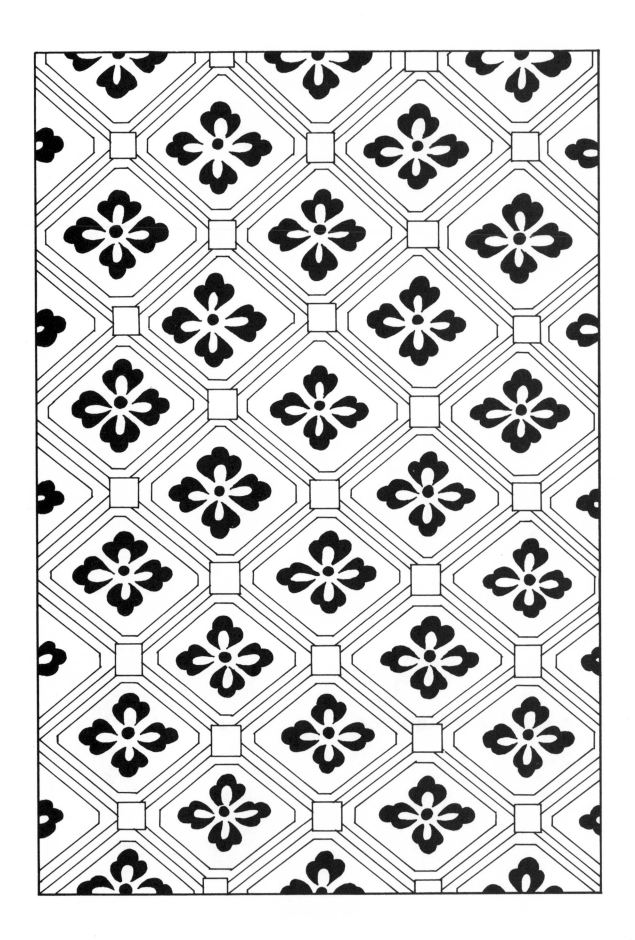

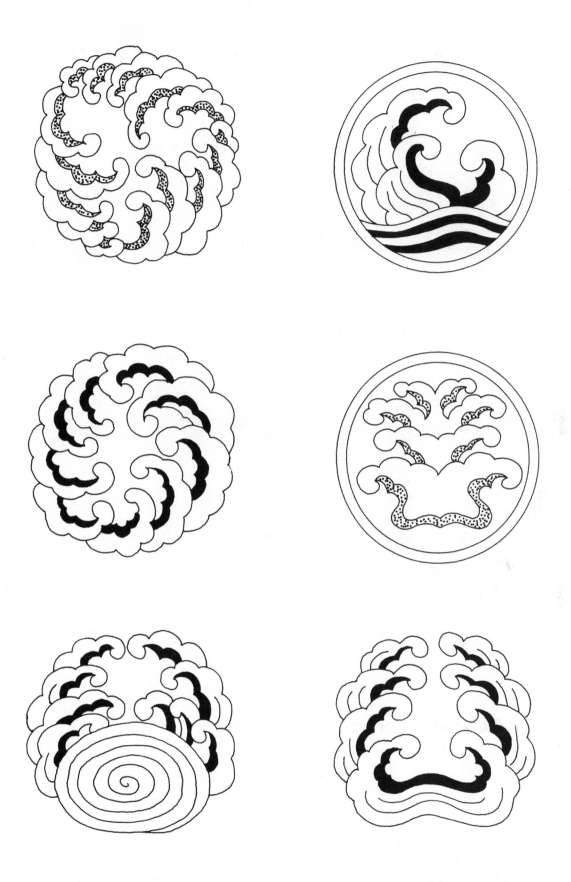

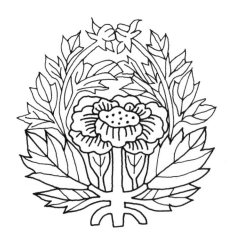

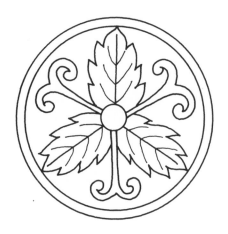

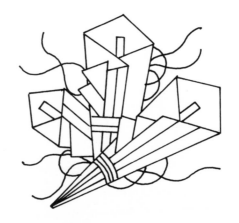

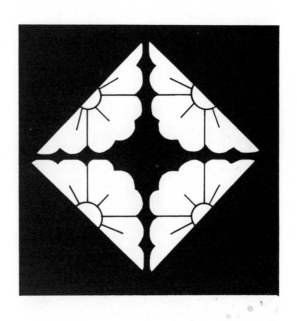

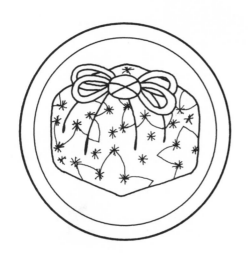

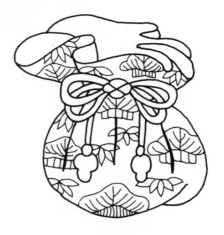

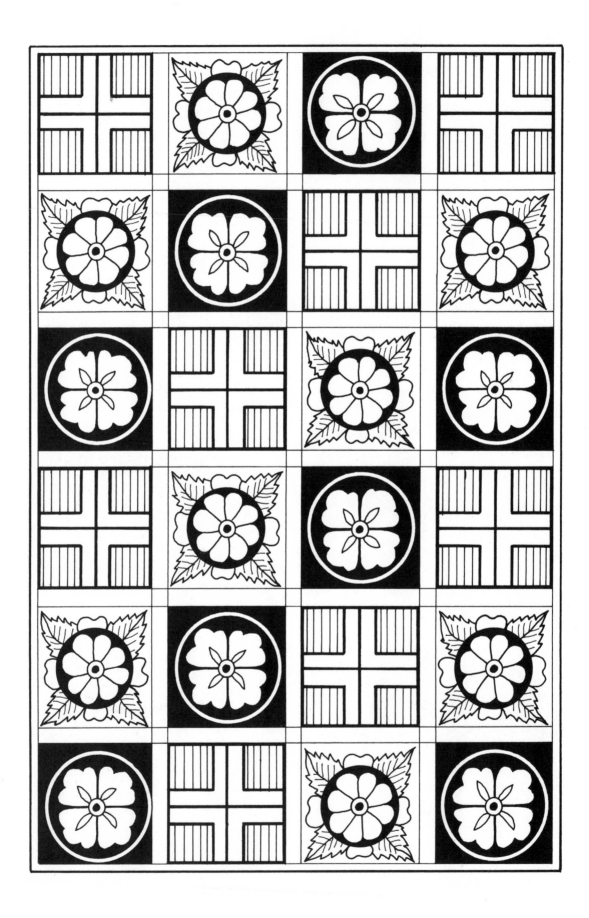

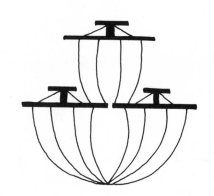

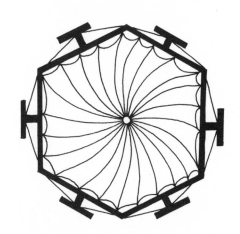

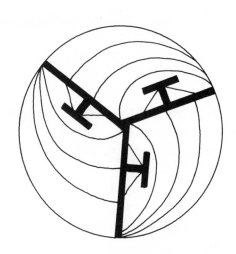

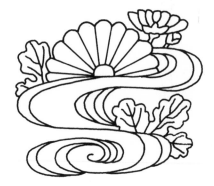

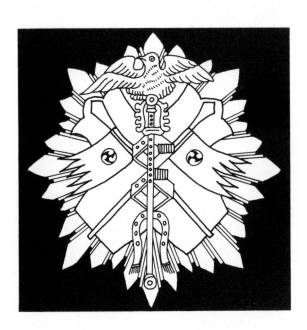

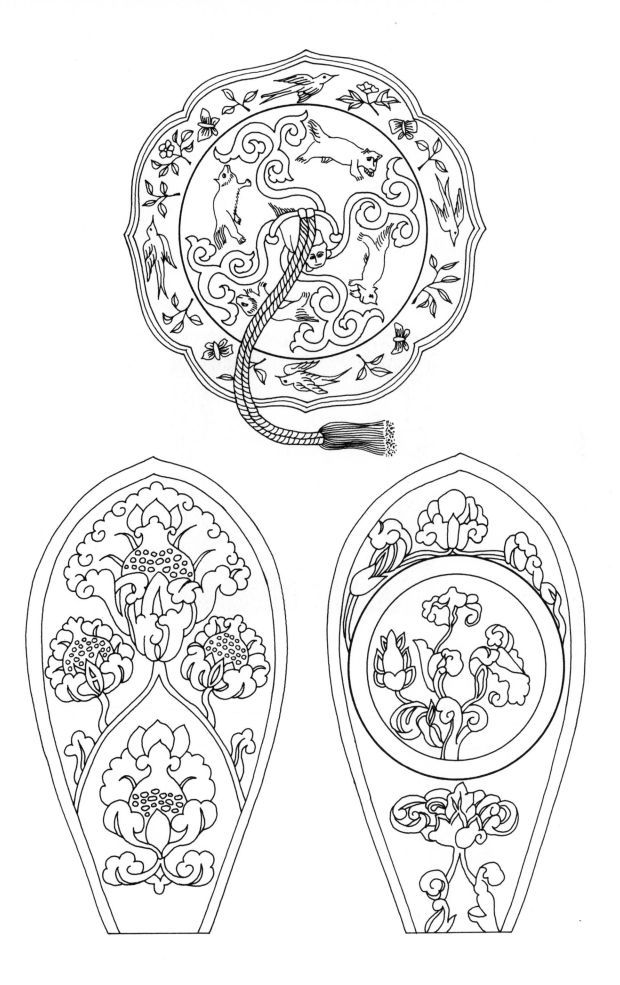

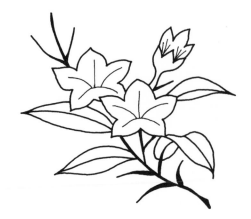

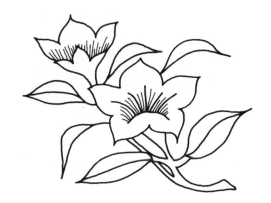

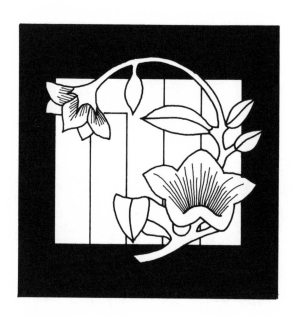

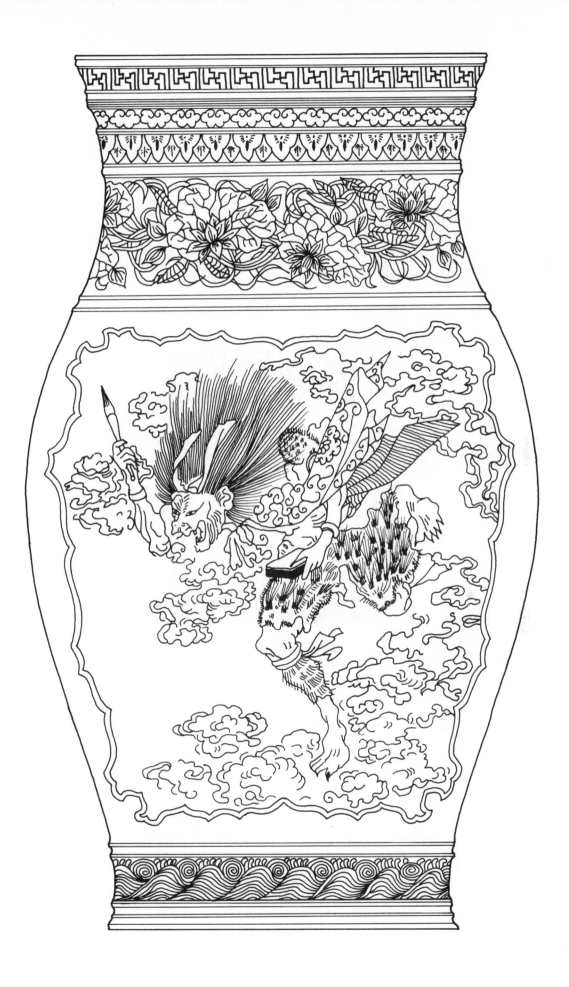

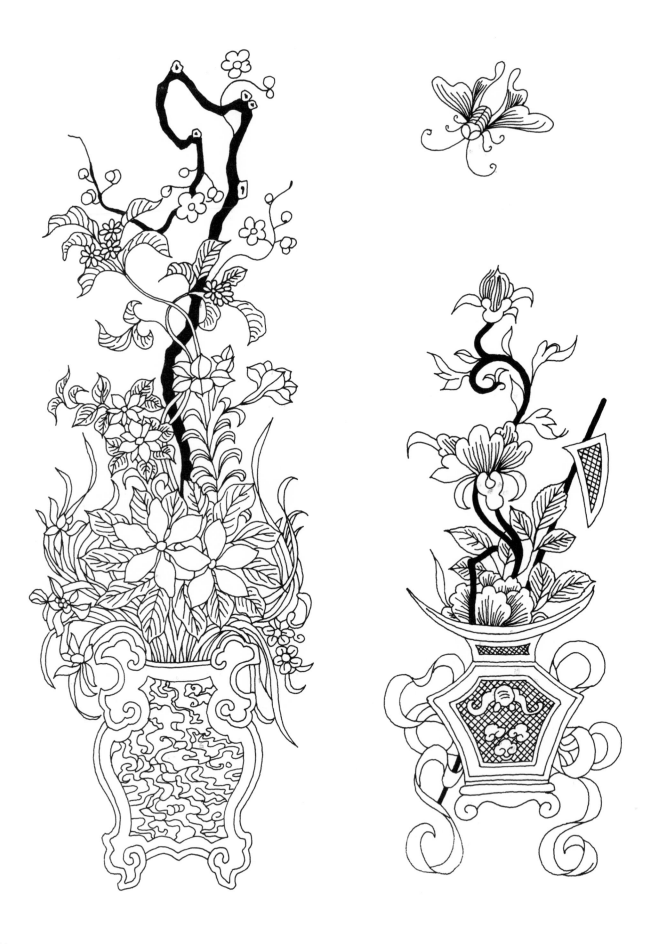

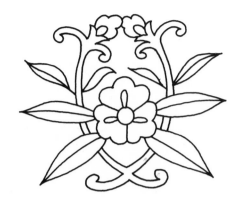

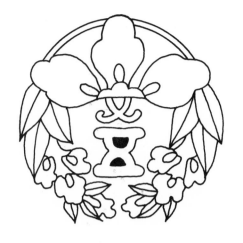

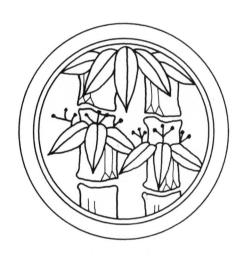

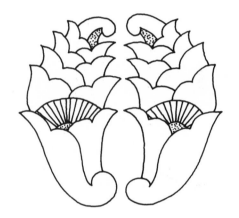

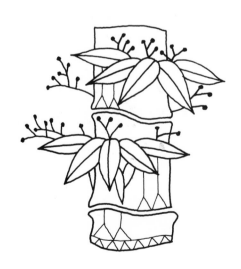

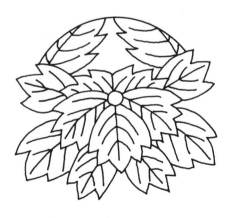

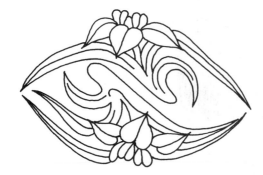

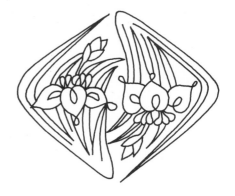

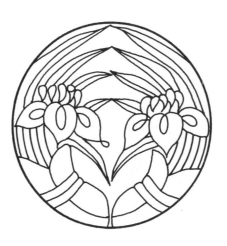

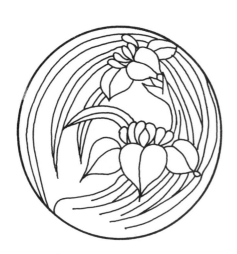

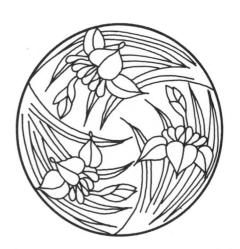

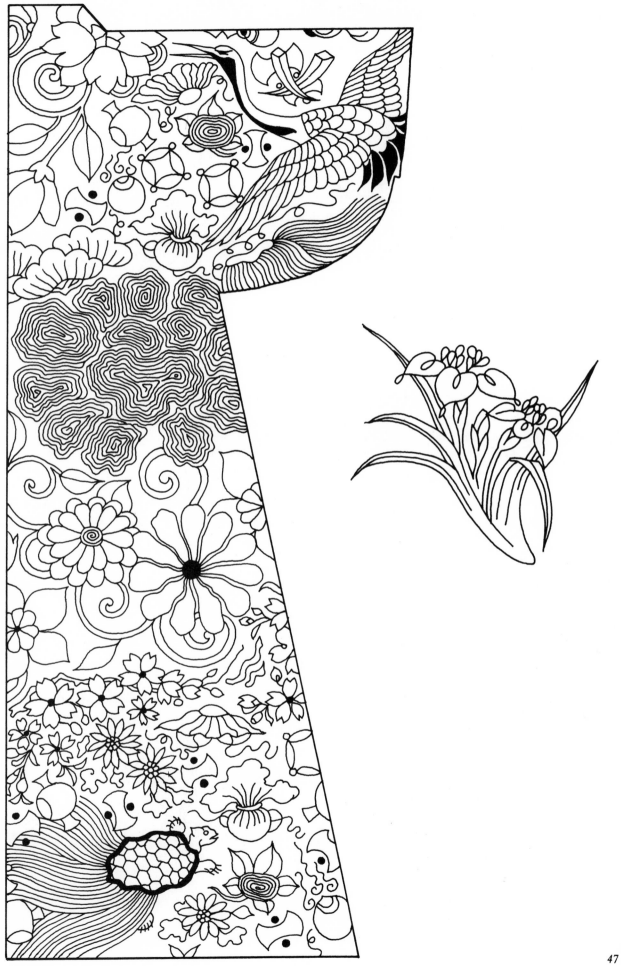

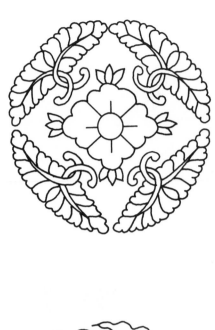

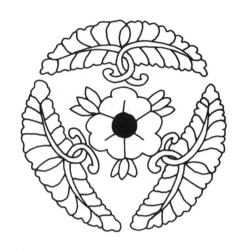

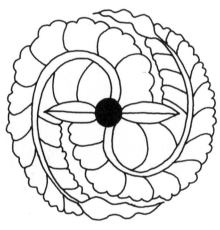

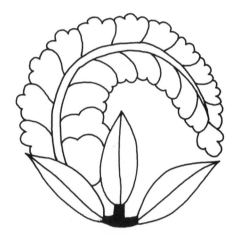

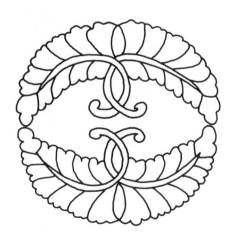

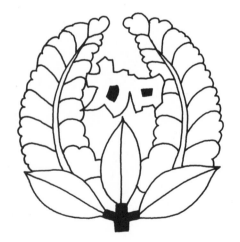

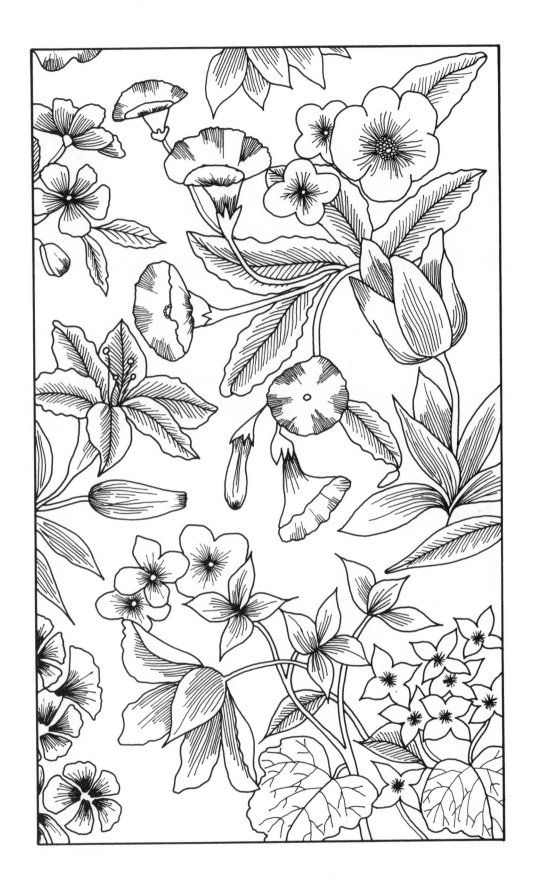

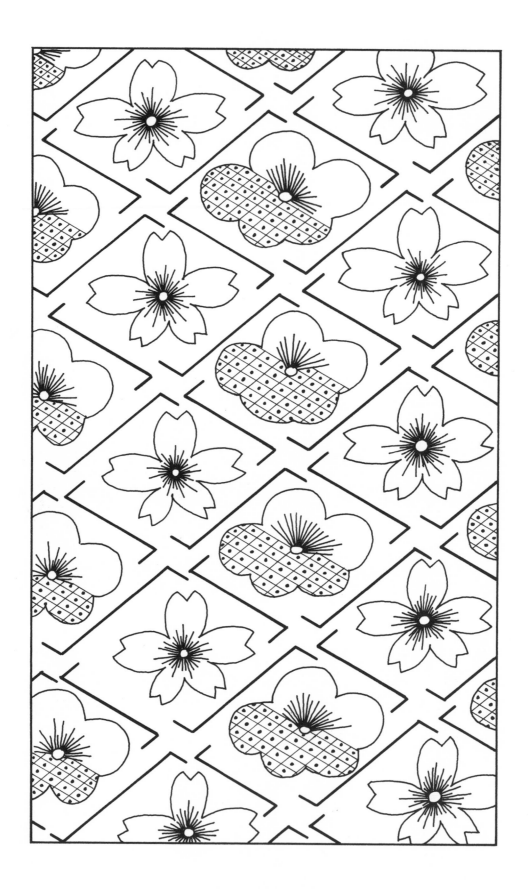

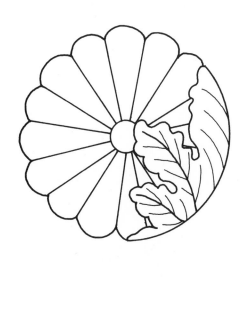

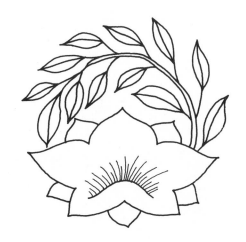

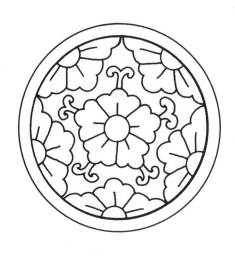

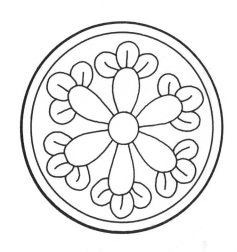

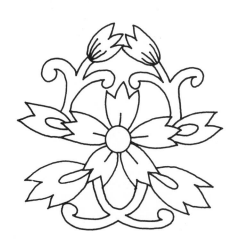

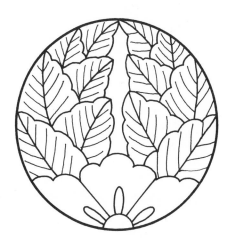

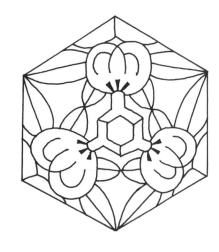

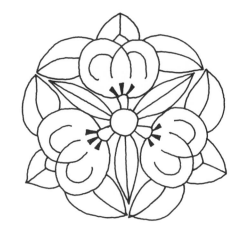

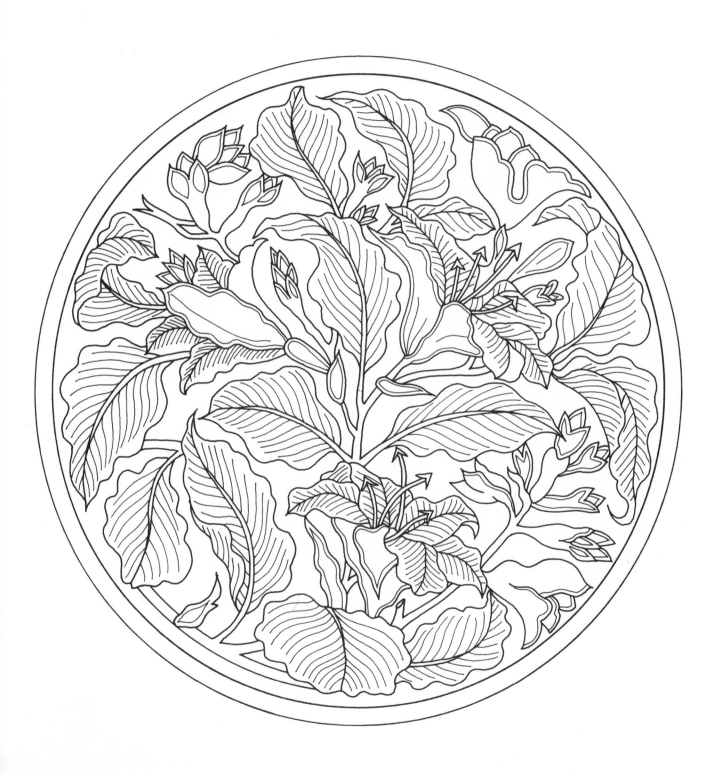

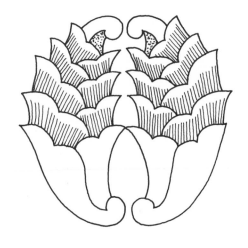

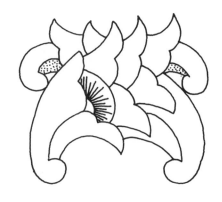

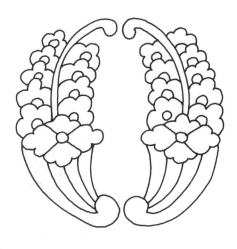

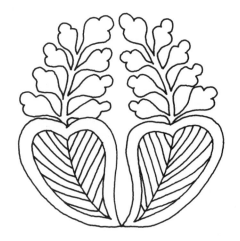

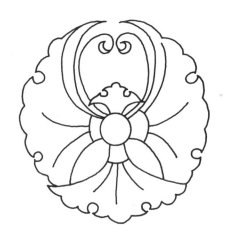

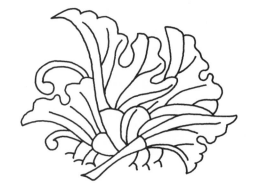

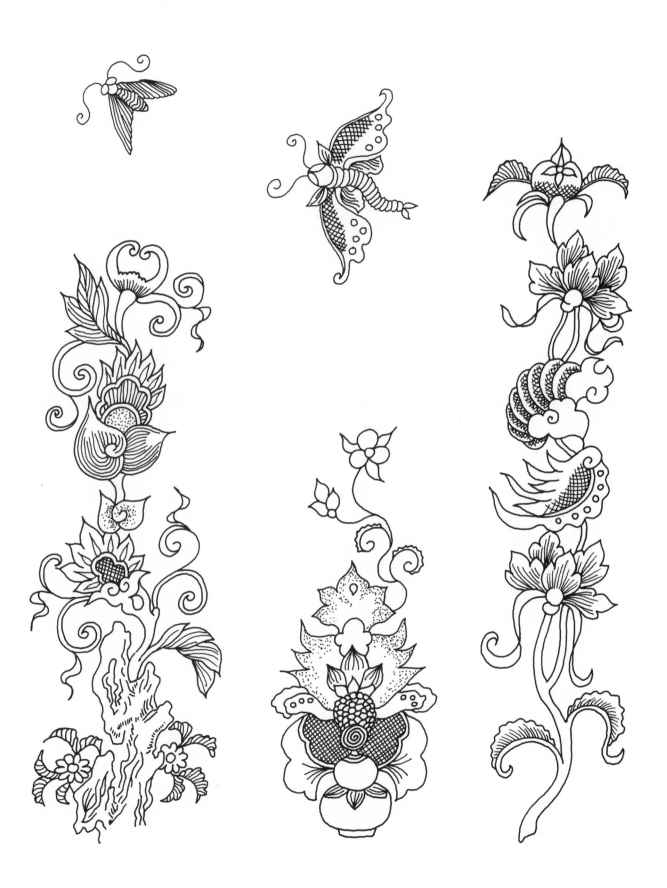

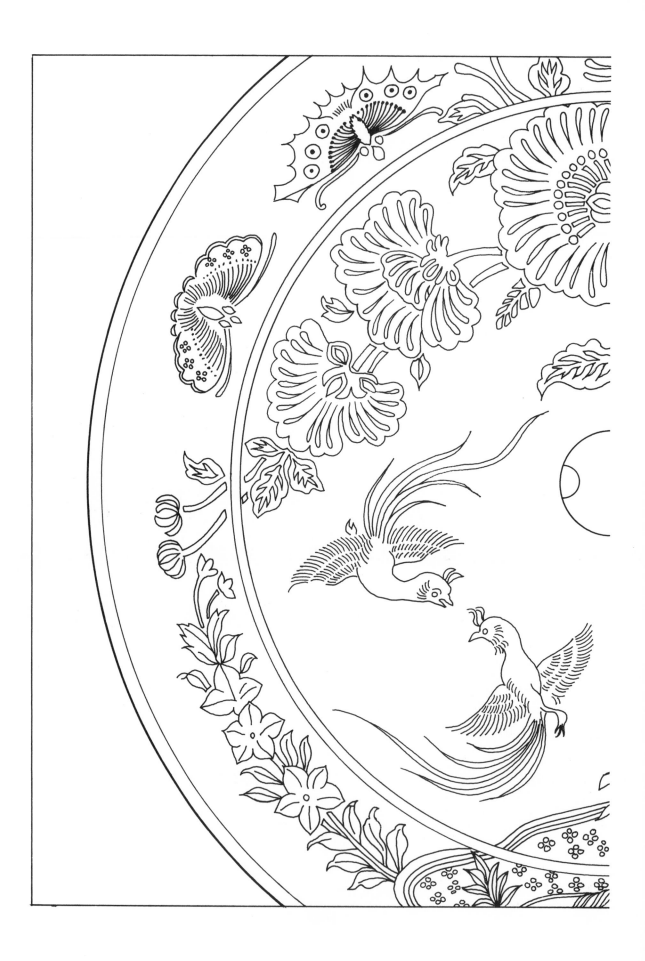

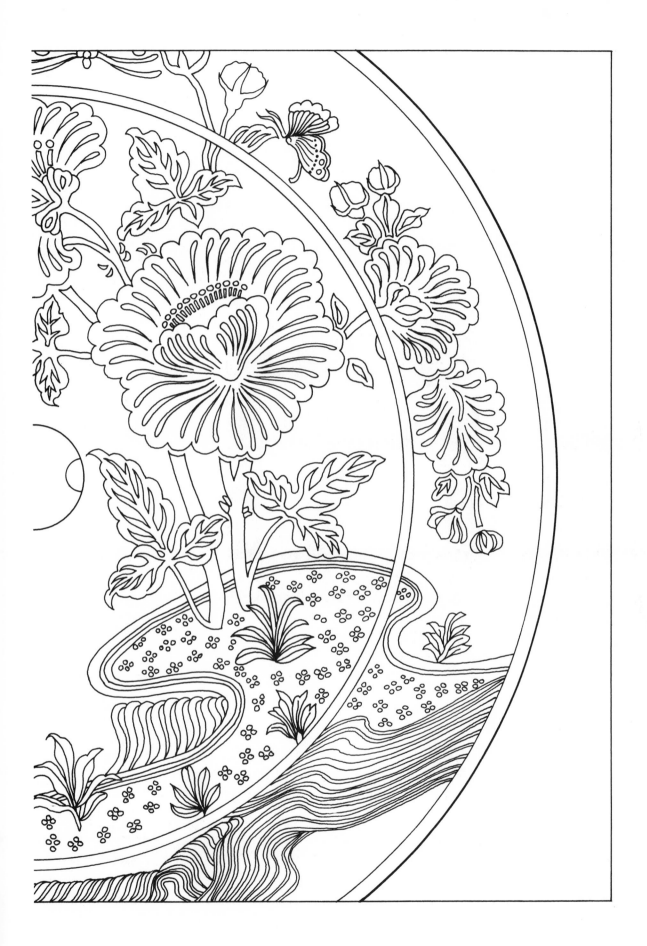

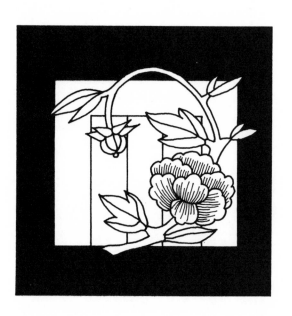

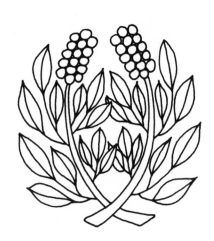

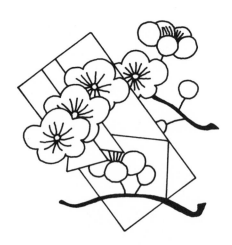

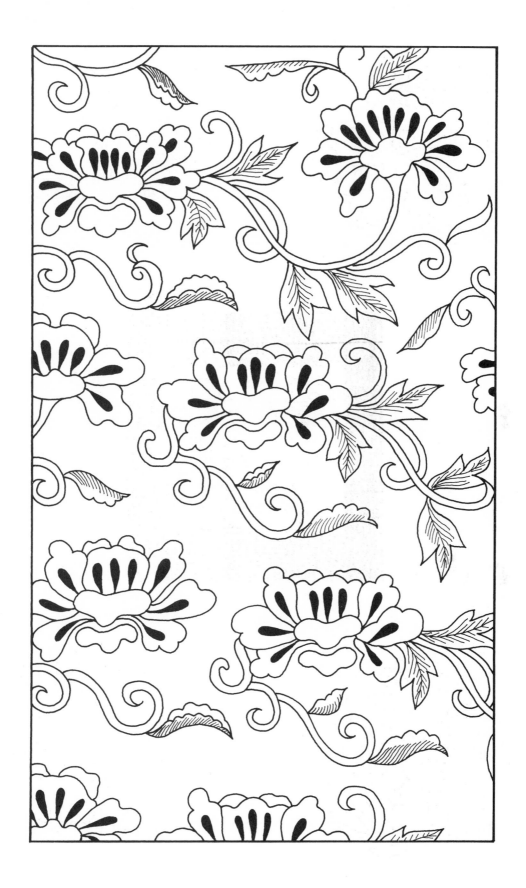

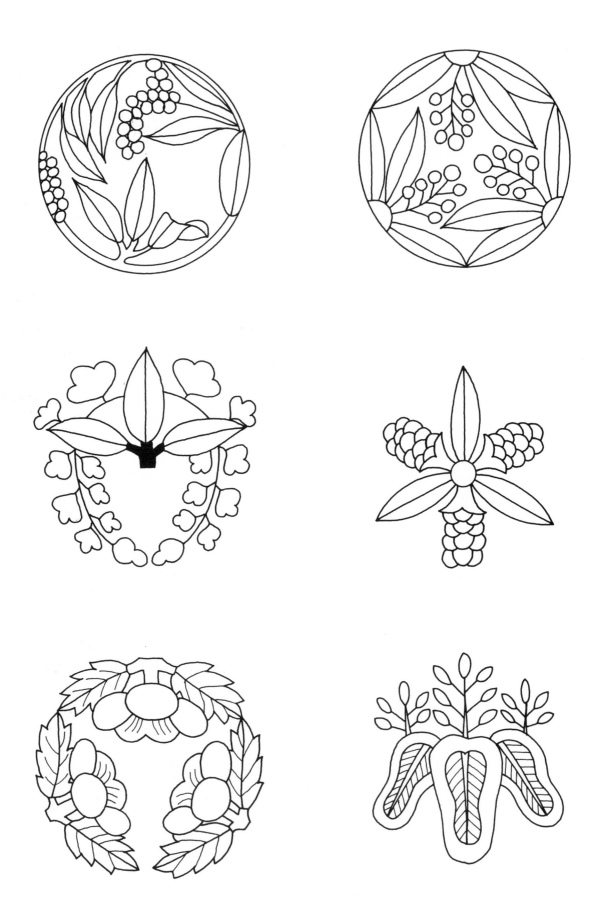

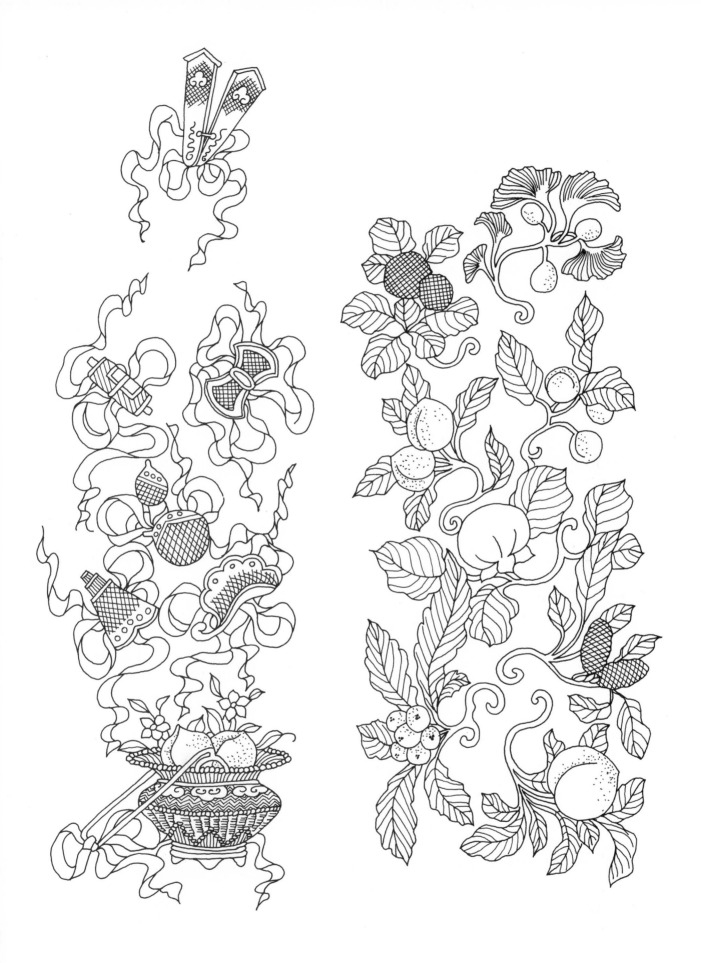

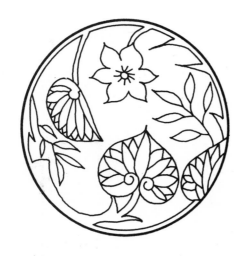

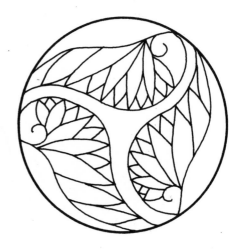

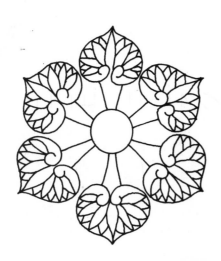

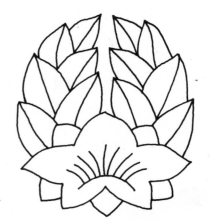

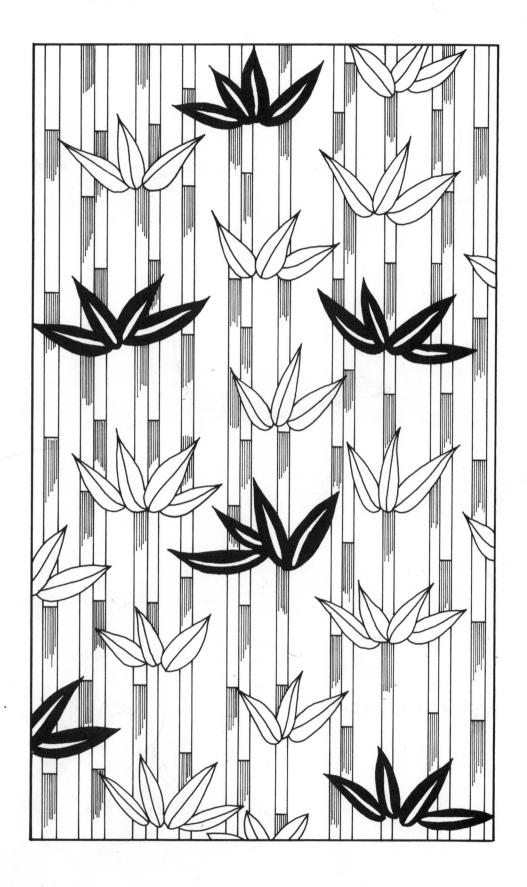

63

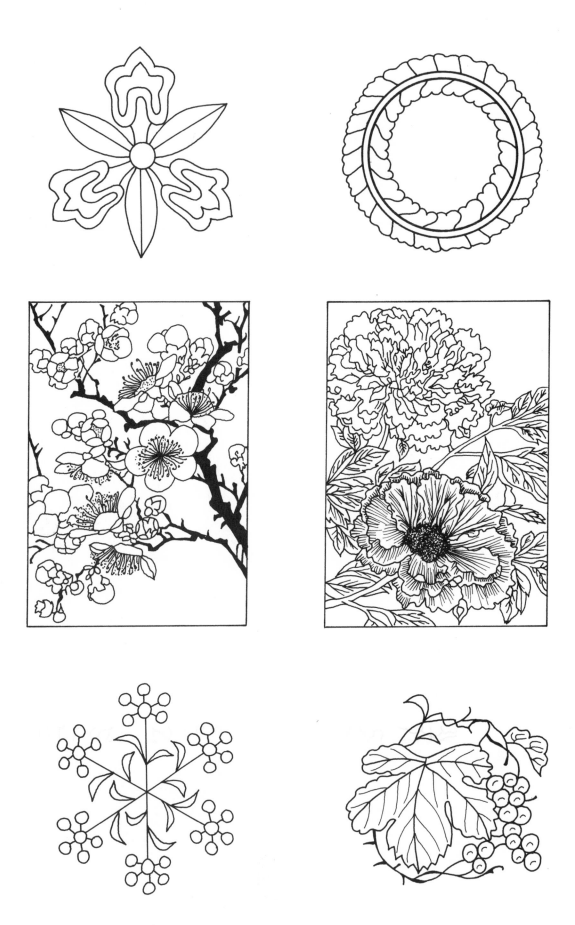

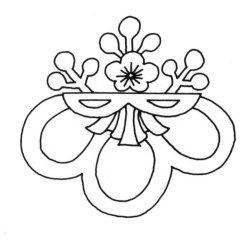

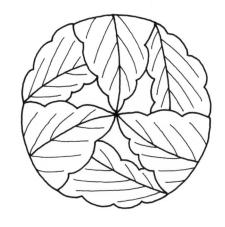

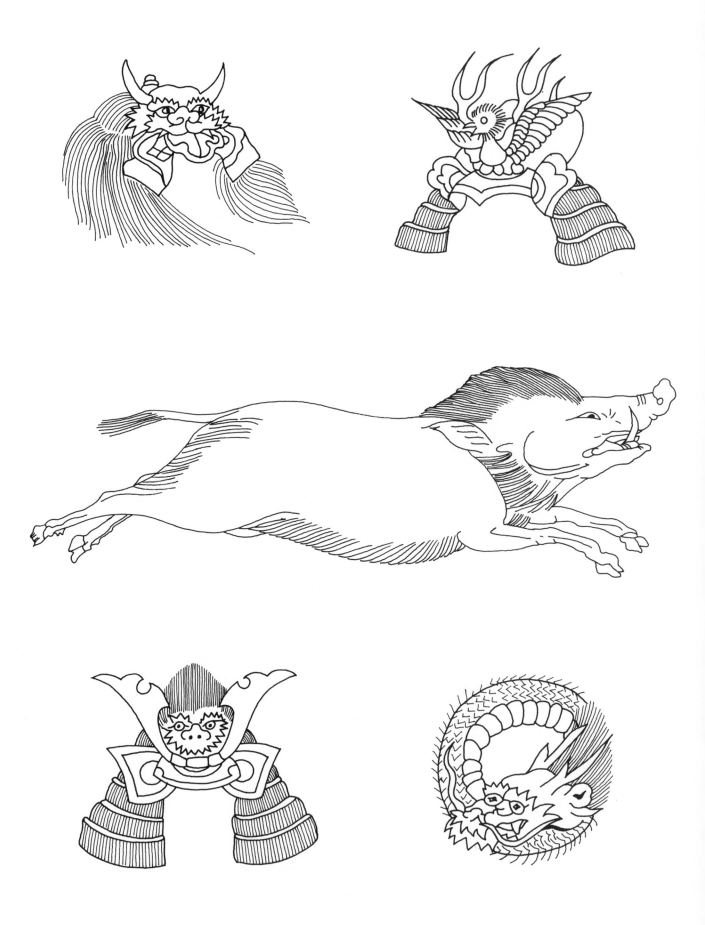

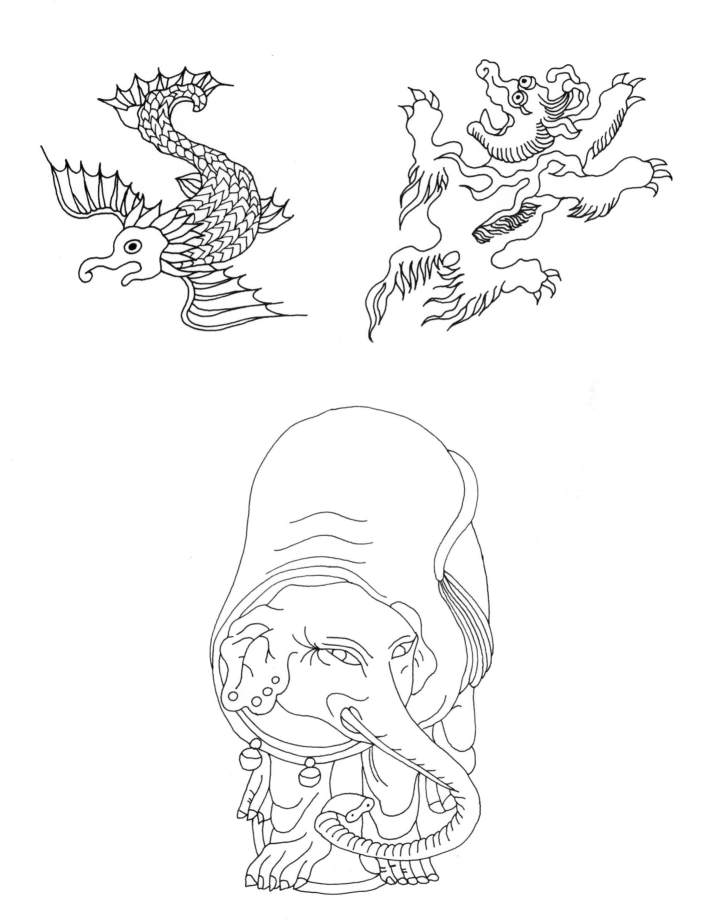

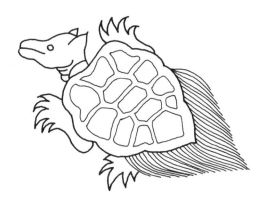

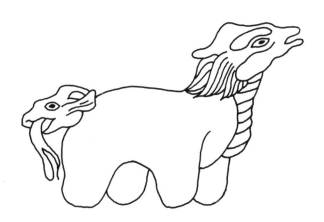

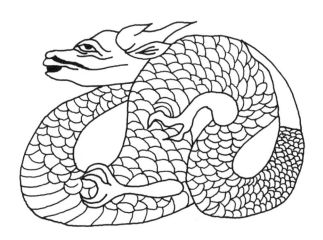

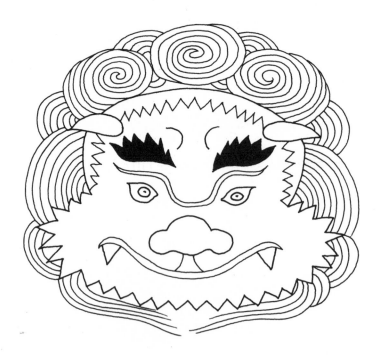

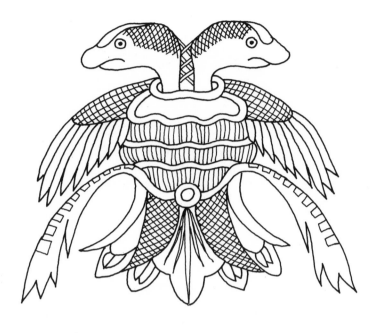

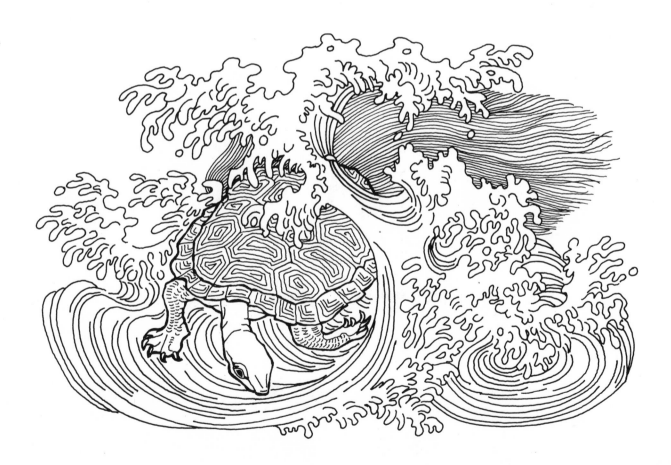

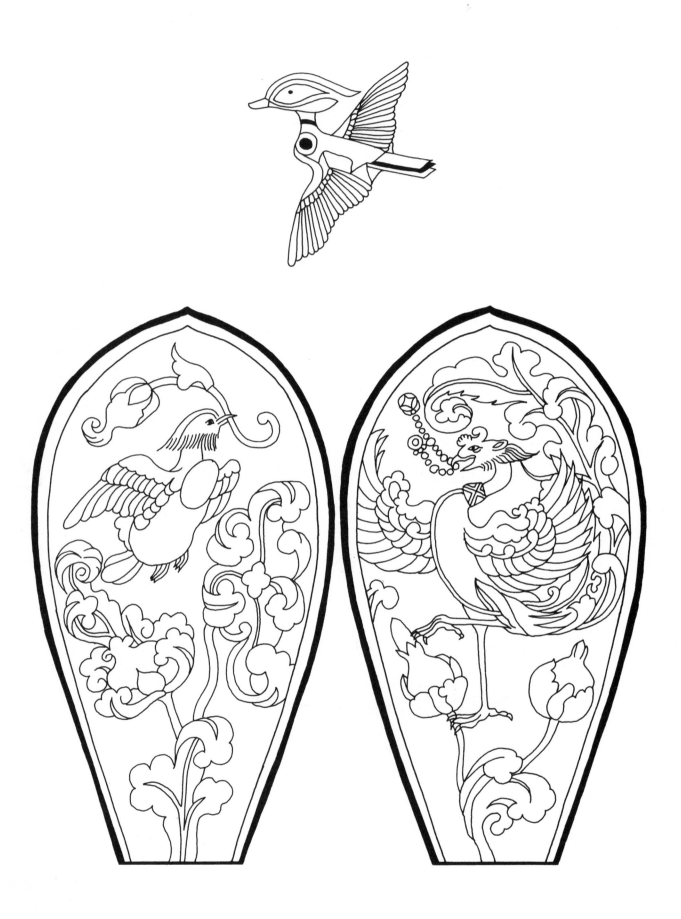

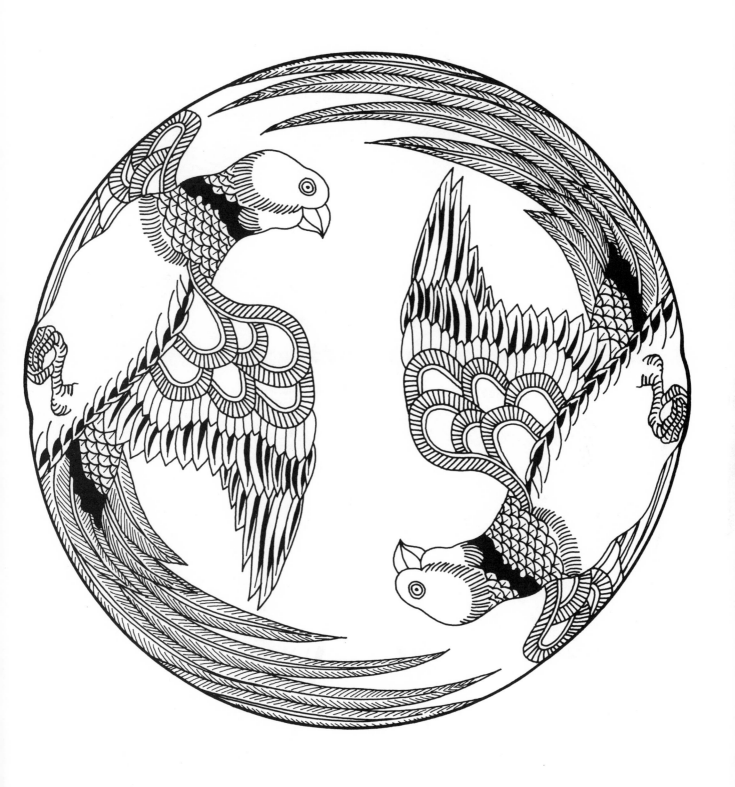

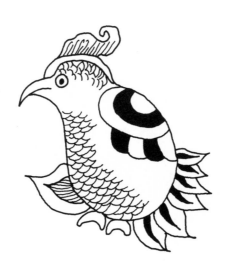
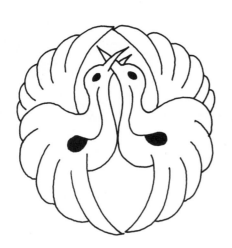
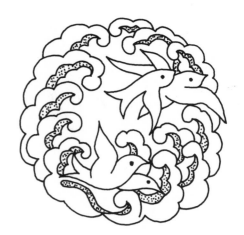

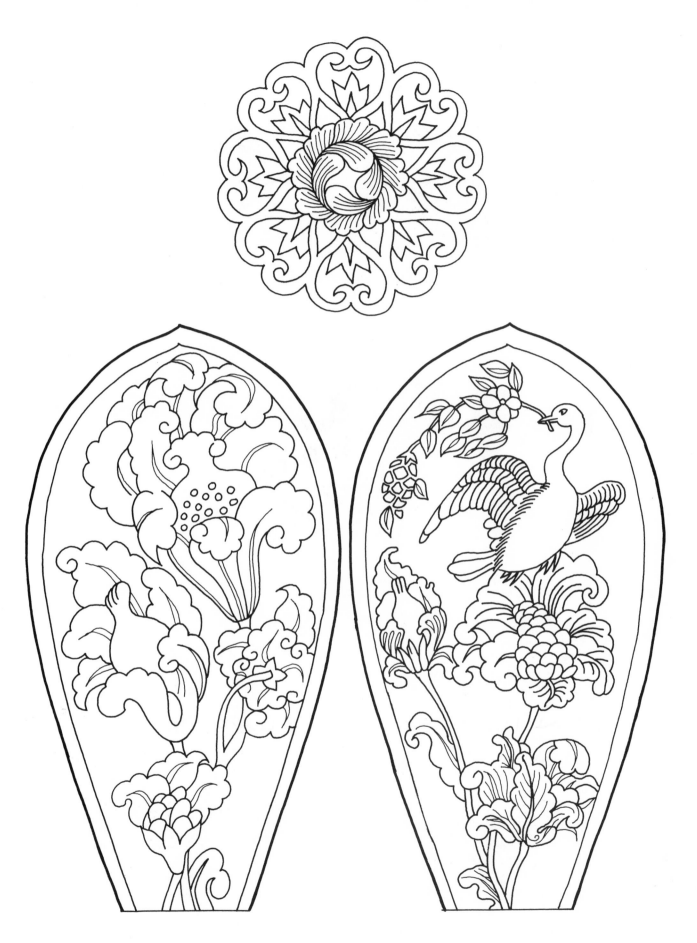

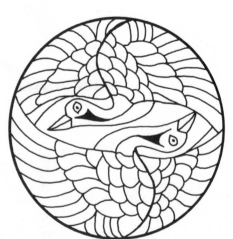

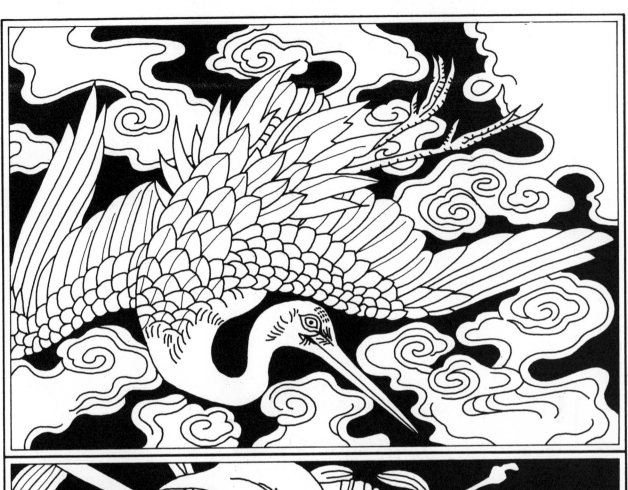

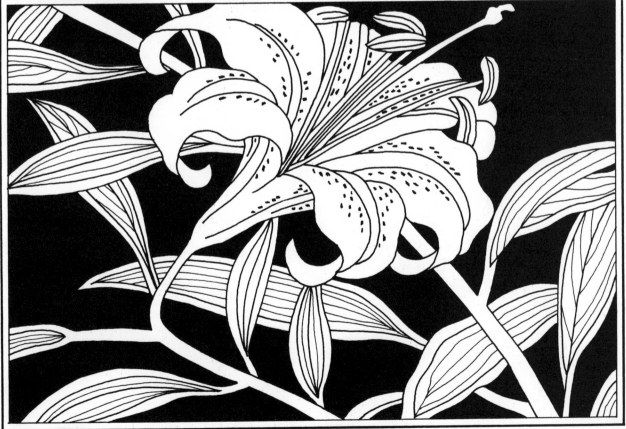

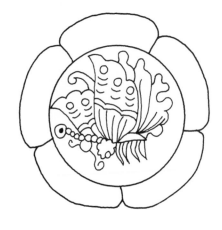

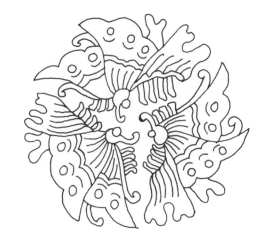

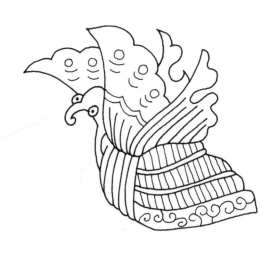

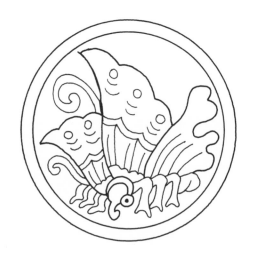

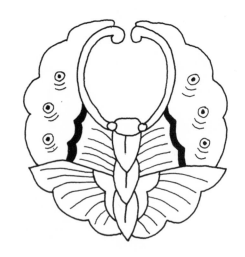

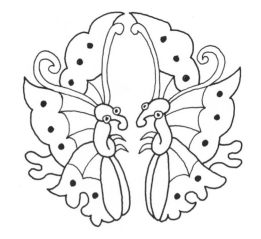

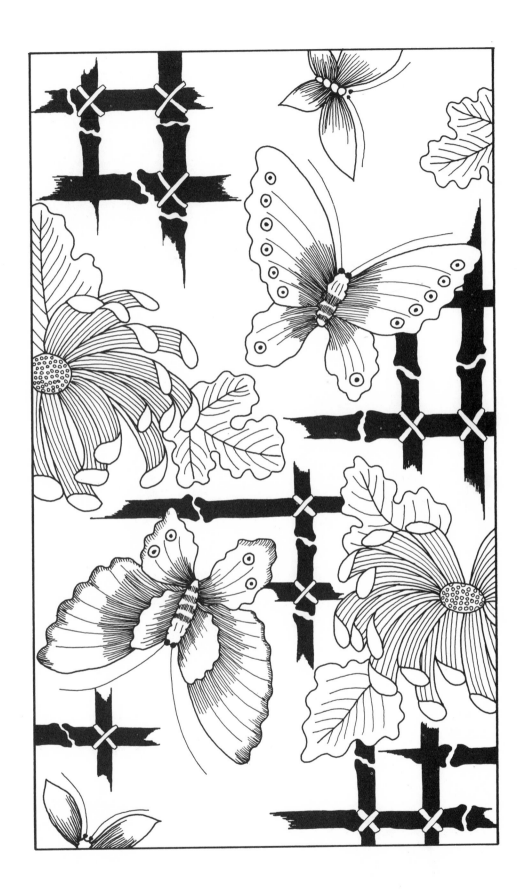

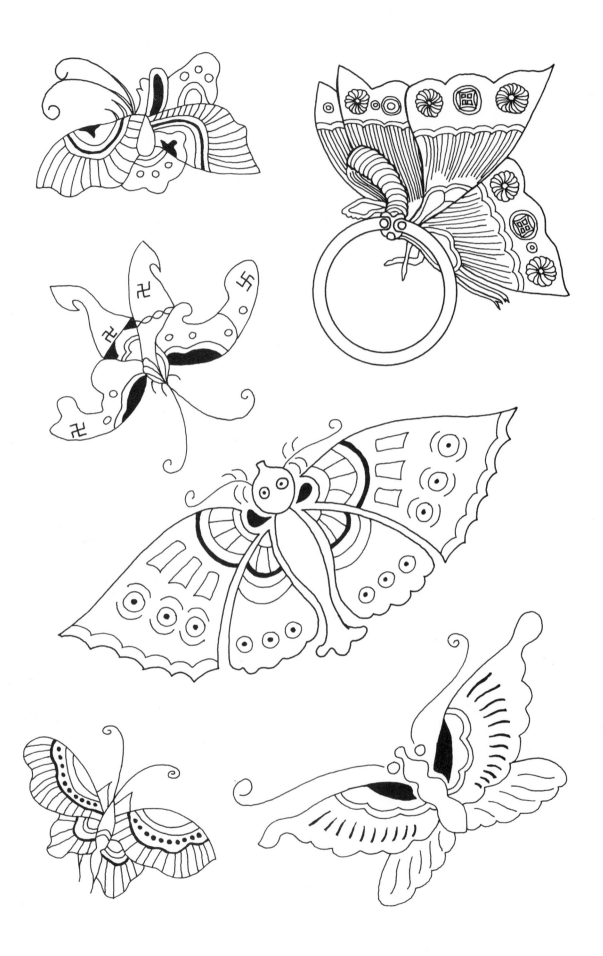

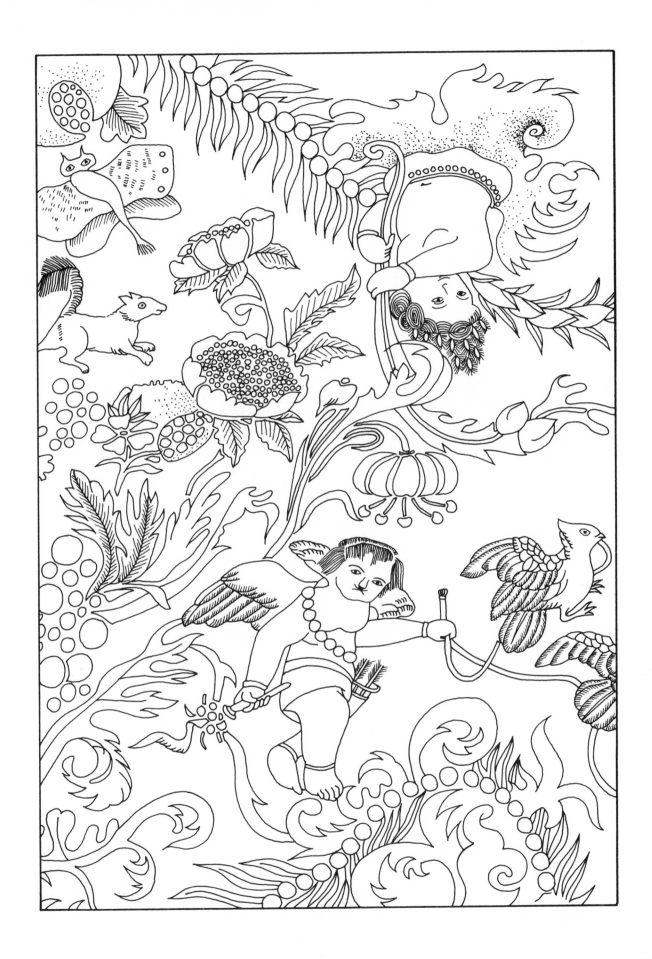

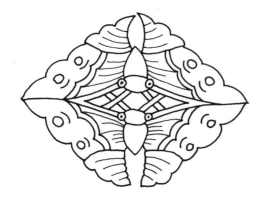
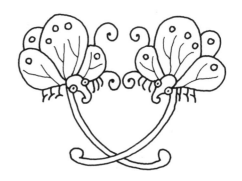
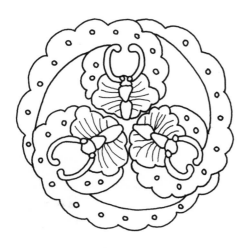
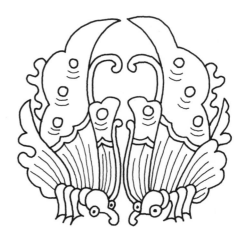

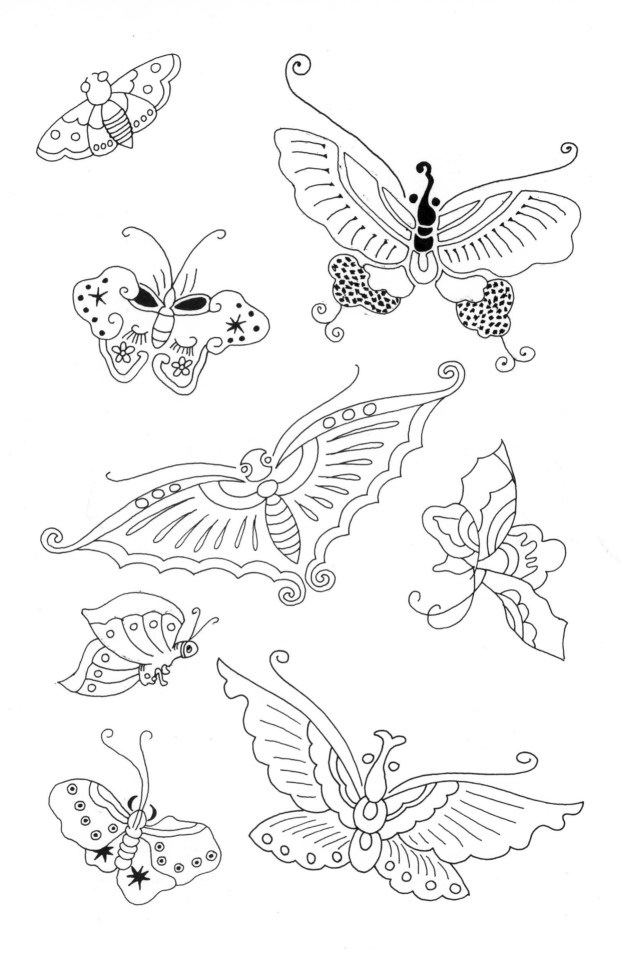

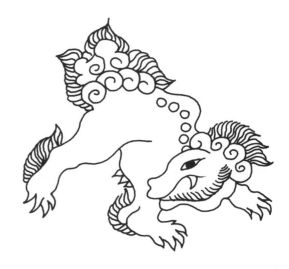

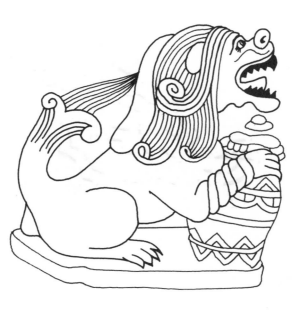

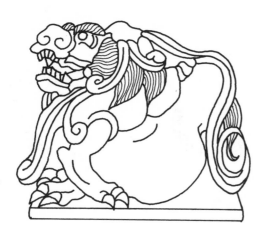

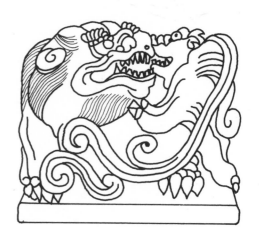

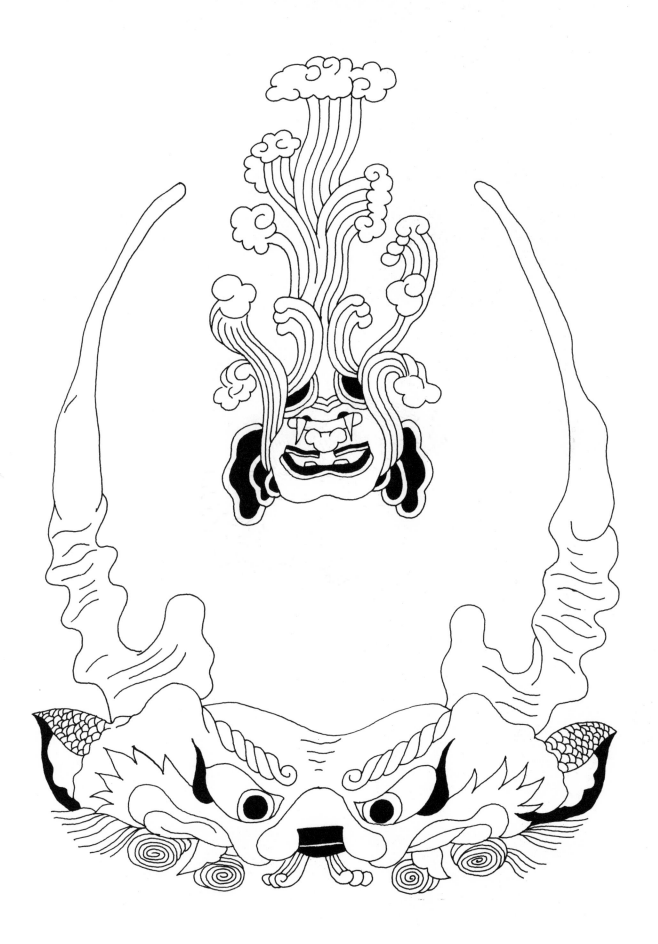

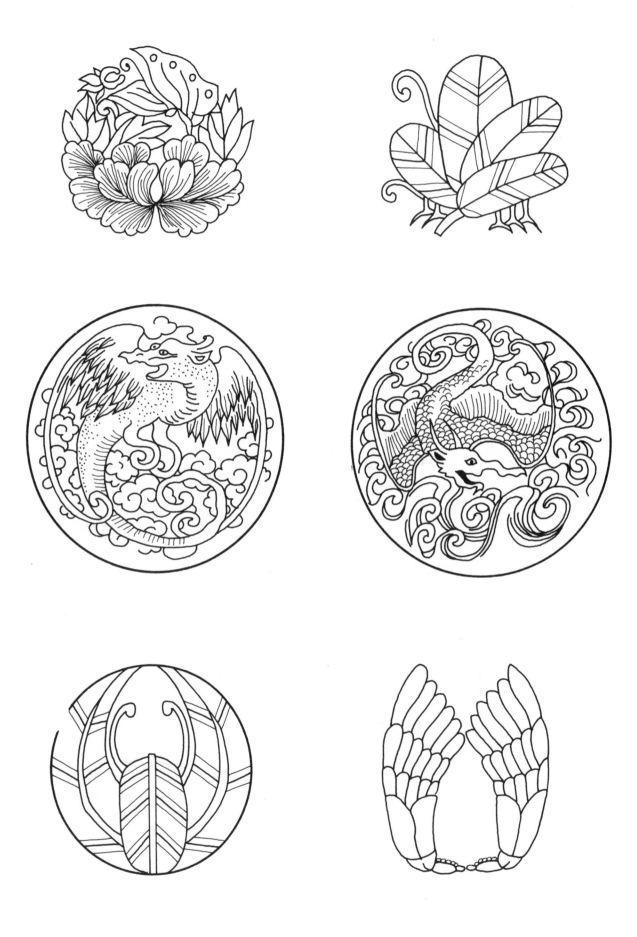

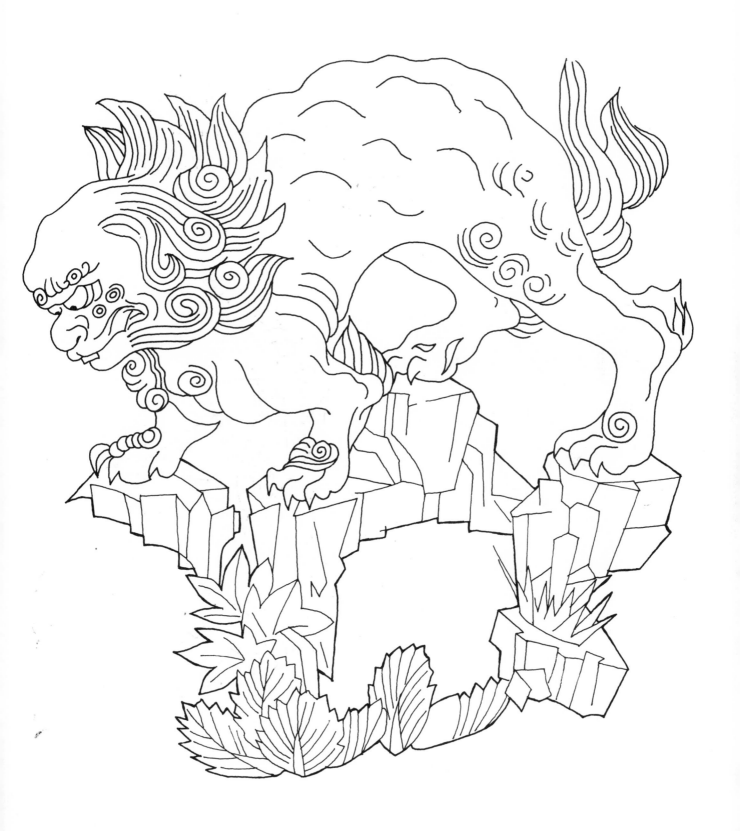

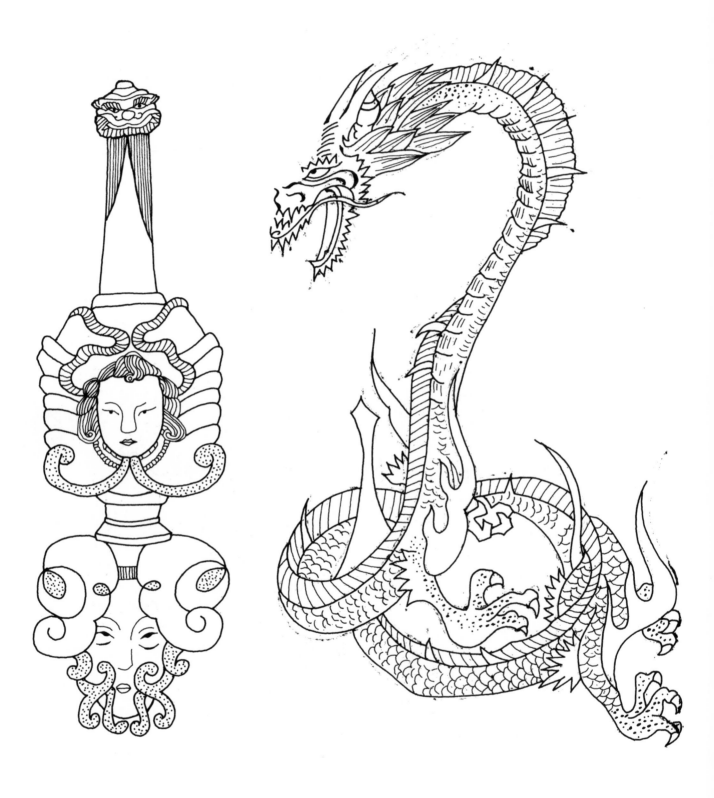

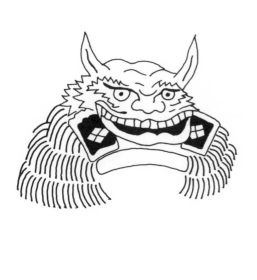

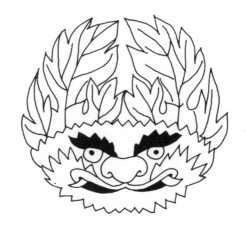

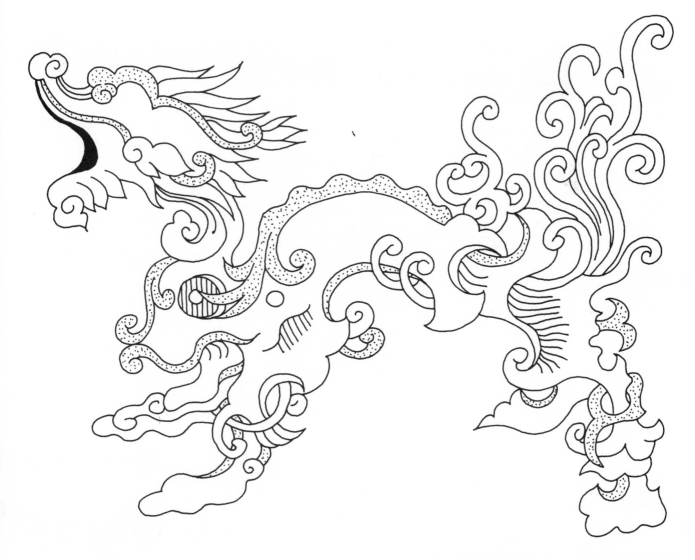

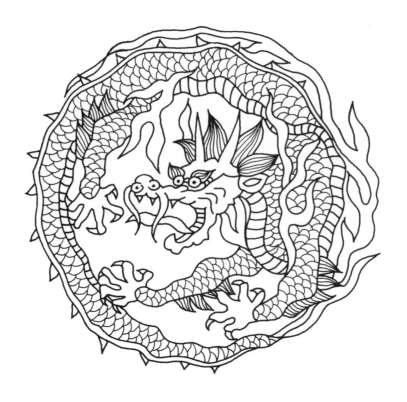

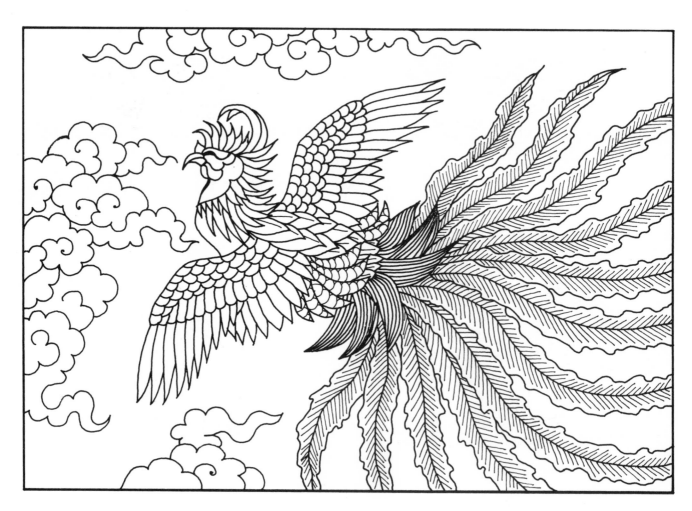

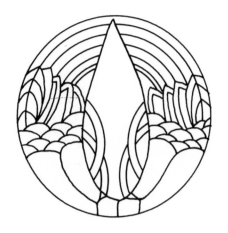

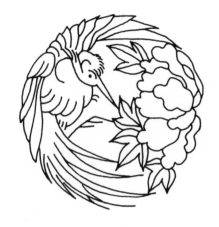

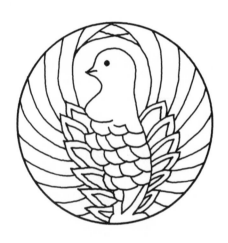

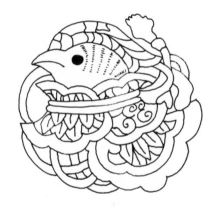

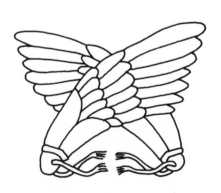

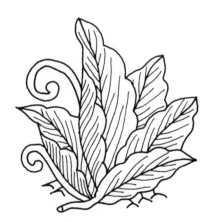

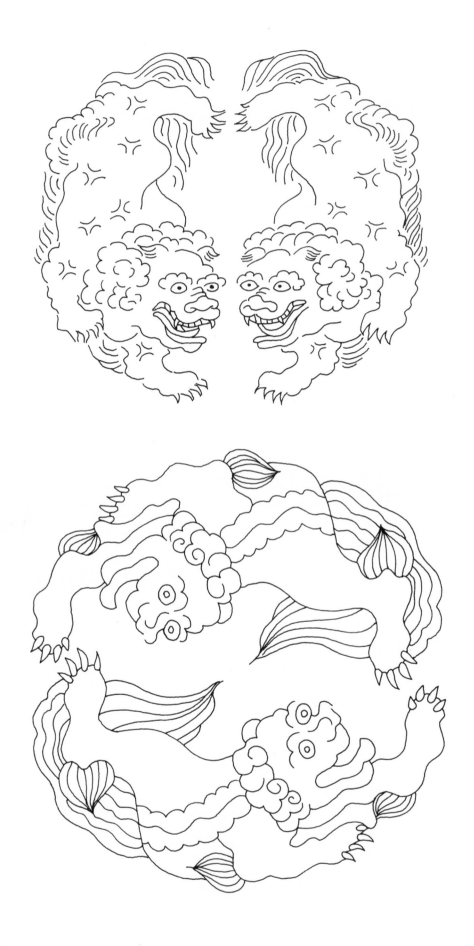

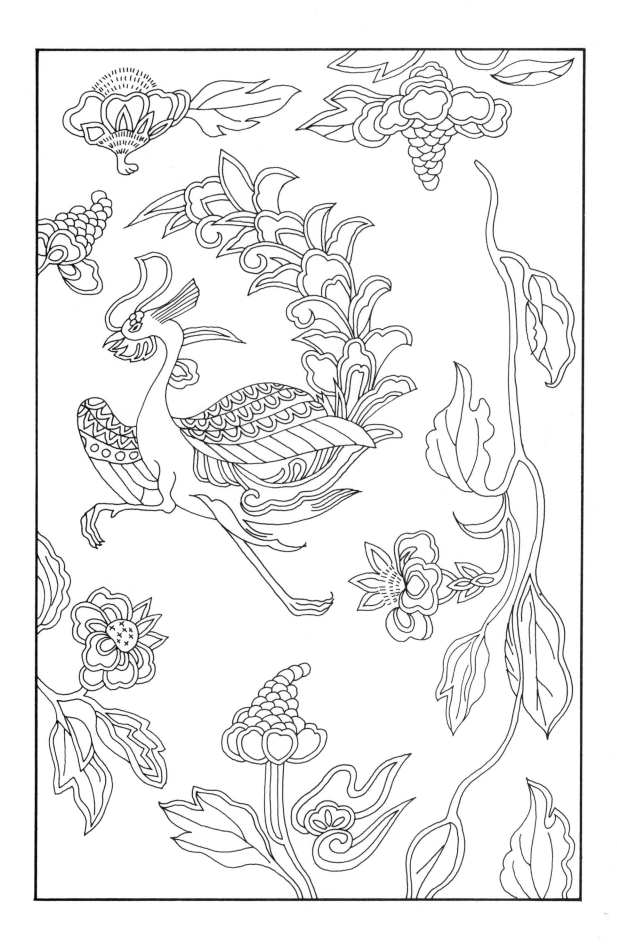